BLACK STYLE

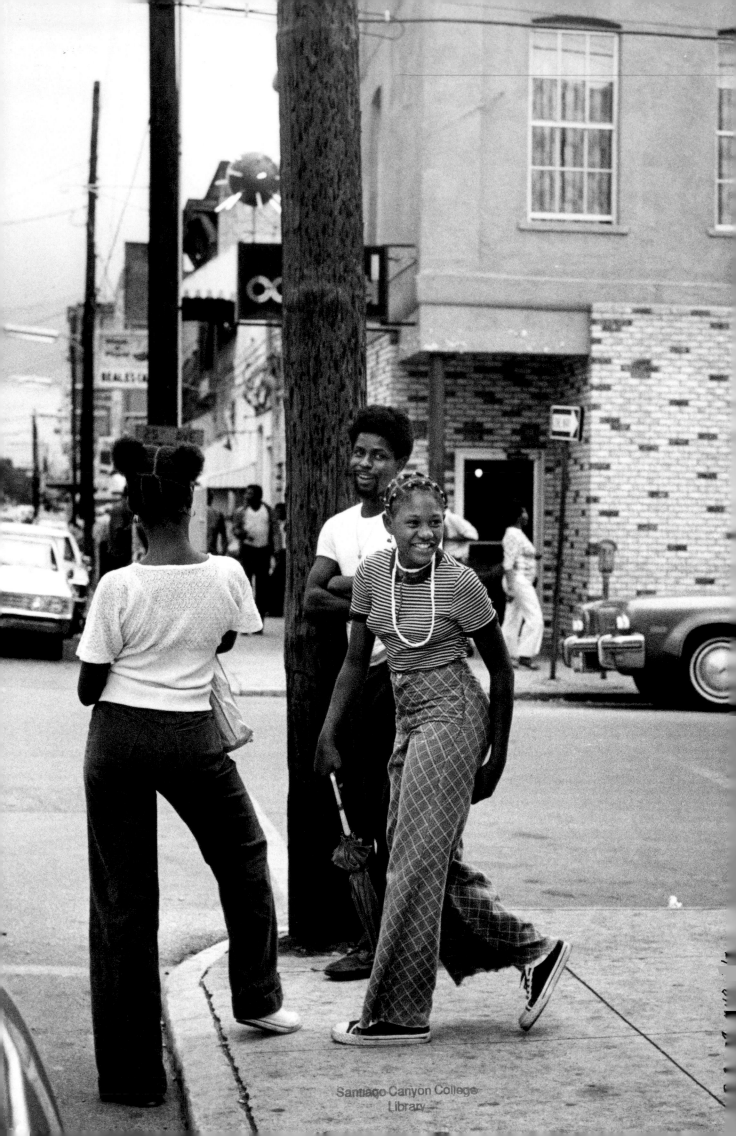

BLACK STYLE

edited by Carol Tulloch

First published by V&A Publications, 2004
V&A Publications
160 Brompton Road
London SW3 1HW

Distributed in North America by Harry N.
Abrams, Inc., New York

Designed by Maria Beddoes

Front cover: Photograph by Hainsley Brown.
Styling by Cynthia Lawrence-John
Model: Larissa, with thanks to Dean at
Oxygen Model Management
Back cover: Photograph by Horace Ove.
Notting Hill Carnival, 1970s
Frontispiece:
Fifth Street, Meridian, Mississippi, 1974
© Val Wilmer

Printed in Singapore

ISBN 1 85177 4246
Library of Congress Control Number
2004103247

A catalogue record for this book is available
from the British Library

V&A Publications
160 Brompton Road
London SW3 1HW
www.vam.ac.uk

CONTENTS

LIST OF CONTRIBUTORS

Carolyn Cooper,
Professor of Literary
and Cultural Studies at the
University of the West
Indies, Mona, Jamaica.

Carol Hall,
recently completed
Doctorate in Textiles
and Clothing, Iowa State
University.

Susan B. Kaiser,
Professor and Chair,
Textiles and Clothing;
Professor, Women and
Gender Studies, University
of California at Davis.

Karyl Ketchum,
Doctoral Student, Cultural
Studies, University of
California at Davis.

John Picton,
Emeritus Professor of
African Art at the
University of London.

Leslie W. Rabine,
Professor and Director,
Women and Gender Studies;
Professor, French,
University of California
at Davis.

Carol Tulloch,
Senior Research Fellow in
Black Visual Culture,
Chelsea College of Art /
V&A Museum.

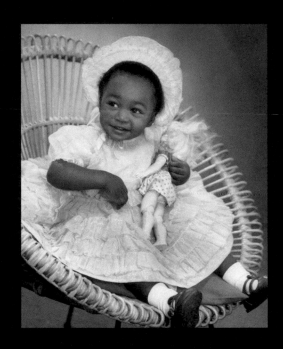

ACKNOWLEDGEMENTS

Without the dedication of the contributors, photographers and lenders this book would not have been possible. I am particularly indebted to Carolyn Cooper and John Picton who provided additional material to help bring balance to the book. The distance between England and America, and the flurry of demands from me, did not deter Susan Kaiser's co-ordination of her three co-contributors. Kobena Mercer has been encouraging of this project and the accompanying exhibition from the early stages of its development. His committed support is clear in his foreword. Pete James of Birmingham Central Library has been unstinting in his support, in both arranging loans and providing leads to other sources. Jon Newman of Lambeth Archives, Camilla Jackson of the Photographers' Gallery, the staff at PYMCA, and Victoria Loughran all responded to my requests and questions with speedy professionalism. Vanley Burke, Val Wilmer, Lydia Evans, Max Kandhola and Syd Shelton provided stories to accompany their photographic work which enhanced the introduction.

Working with V&A Publications has been an enjoyable and edifying experience. The diligence of Mary Butler, Monica Woods, Catherine Blake and Maria Beddoes made the production of the book a much smoother process. In the development of the book, I must also thank other members of V&A staff: Shaun Cole and Carolyn Sargentson for giving their time to comment on early drafts, and Mark Haworth-Booth, Susan McCormack and Sue Lambert for helping to get the project off the ground.

Black Style is dedicated to Alfred Valentine Tulloch and his passion for clothes; and Syd, for always being there.

FOREWORD

Looking at the choices that black people make when it comes to clothes, dress and appearance, Black Style reveals something curious about the nature of cultural identity. While the ruling fiction of 'race' may suggest a fixed and monolithic group, what the curators and contributors to this book and exhibition bring to light is the sheer range and variety of the expressive practices that make black style a distinctive and recognizable 'fact' of modern life. As it weaves its way through cities and communities in West Africa, the Caribbean, the United States and black Britain, the book highlights a dazzling array of cross-cultural patterns and variations in the medium of dress and hairstyle. The attention to the tiny details that catch your eye; the nuances, inflections and accents that make an impression; the subtle traffic of signs taken out of one code and translated into another; all suggest that black style is not the uniform expression of some unchanging ethnic 'essence', but is best understood as an act of aesthetic agency inscribed into a material world of immense social disparity.

The concept of 'style' has an ambiguous history which is relevant here. Because it concerns the formal and expressive aspects of communication rather than the material substrate or medium, 'style' lies at the heart of the classifications and categorizations that distinguish one artist, or movement, or period, from another. The ability to compare and contrast depends on the grouping of objects according to shared stylistic features. On the other hand, the 'artistic will' that was held to express itself as the collective spirit of the age was frequently identified in the evolutionist paradigm of the nineteenth-century sciences, by an ethnicist view of 'style' as synonymous with group spirit or 'ethnos'. Such thinking was challenged by, among others, the linguistic perspective that saw 'style' as a semiotic issue of formal variation within a shared discourse. As the term entered into the investigation of sub-cultural identities in post-war sociology, the expressive subject of style, once identified with entire nations, peoples and historical periods, and then with schools, salons and individual artists, was now re-cast in the parade of post-war youth cultures that drew their inspiration from black American and black British sources.

Inviting us to examine what is 'black' about the black style in question, Carol Tulloch and her colleagues show the insights to be gleaned from giving an equally close quality of attention to both the social, historical and cultural contexts in which meanings are encoded by stylistic choices, and to the material substrate – skin, hair, fabric – that style works upon and cuts into when it inscribes itself into the culture. To the extent that 'black style' is globally recognizable today, it is an object of shared fascination across the board, and the dynamic interplay of aesthetic inventiveness and material context is as volatile and unpredictable as ever. In showcasing the creative possibilities of black British style, in the accompanying exhibition, the Victoria and Albert Museum holds a mirror to the changing face of our surroundings.

Kobena Mercer
Visual Culture and Media,
Middlesex University

2003 © Bryn Reade

'IT'S GOOD TO HAVE THE FEELING YOU'RE THE BEST'[1]
INTRODUCTION

CAROL TULLOCH

The dress culture of people of African descent is rich in history and cultural significance. It is an area of study that is slowly developing, in the notable recent works looking at the global impact of African dress (Rabine 2002; Trenton 1999), and style connections between black Britons, African Americans and Jamaicans (Tulloch 1999; Lewis 2003). [2] *Black Style* builds on this vein of dress studies, focusing on the ways in which different parts of the African diaspora have managed their sense of self and sense of place through the styling of the body. The book provides a space where specialists on dress and/or black studies from different parts of the African diaspora can expand on this phenomenon. The countries and regions presented here are West Africa, Jamaica, the United States and Britain. Of course this extends to other parts of the Caribbean, Europe and North America. The contributors have engaged with these issues through different approaches: literature and black studies; cultural and visual studies; textile and dress history. They deal with the important question of how black style has emerged and been identified in various communities and cultures within the African diaspora.

Defining black style is complicated, partly because of the intellectual sensitivity that surrounds the use of the word 'black'. It is used here to refer to people from the African diaspora who share the legacy of the rupture caused by the African slave trade. In making such a specific definition *Black Style* has gone against the grain of some academic thinking. For example, Stuart Hall and Mark Sealy in their book *Different* discuss the work of contemporary black photographers from differing cultural backgrounds. 'Black' is defined, in this context, through the shared connection these artists have in the 'historical experience of living in a racialized world'. [3] For the authors 'black' 'is a politically, historically and culturally constructed category: a contested idea, whose ultimate destination remains unsettled. Indeed the work itself is part of its ongoing redefinition.' [4] The contributions presented in *Black Style* also expose the complexities and 'ongoing redefinition' of what it means to be 'black' through the black body and how it is dressed. For the contributors black style is a plane upon which various issues can be teased out and examined, thereby allowing any individual to engage in a dialogue on the pleasure and pain of being themselves.

The style of dress worn by black people in Britain has had a profound effect on the cultural diversity of the country. In turn adults, youths and children have drawn on other areas of the African diaspora to express their own cultural identity. The remit of the exhibition 'Black British Style' (V&A, October 2004–January 2005), which this book accompanies, is to communicate this aspect of black British culture through garments and textiles, accessories and styling methods, photography, film and music. In part, the book and the exhibition continue the work undertaken by the V&A exhibition *'Streetstyle: From Sidewalk to Catwalk, From 1945 to Tomorrow'* (1994–5), and the

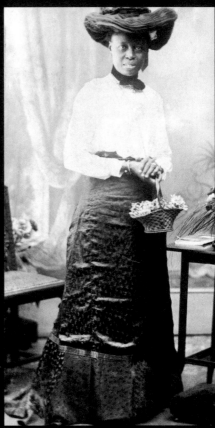

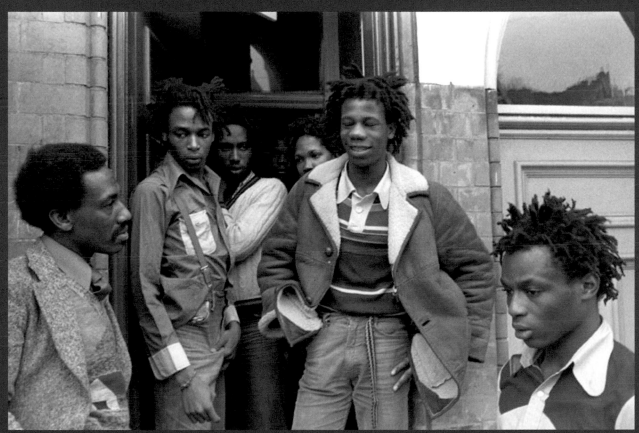

Birmingham, 1970s © Neil Kenlock

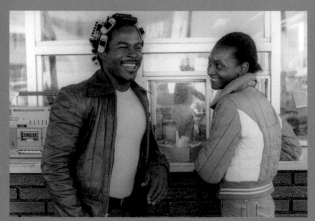
Watts, Los Angeles, 30 March 1984 © Val Wilmer

associated publications *Streetstyle: From Sidewalk to Catwalk* (Polhemus, 1994) and *Surfers, Soulies, Skinheads and Skaters: Subcultural Style from the 1940s to the 1990s* (De La Haye, Dingwall and Daniel, 1996). The focus of these ground-breaking projects was street cultures in the West since the 1940s and their impact on other cultural spheres. Black styles such as Ragga, Caribbean Style and Rastafarianism were included. This publication differs from that initiative in that *Black Style* considers various aspects of black culture and life, not just streetstyle. For example, Susan Kaiser, Leslie Rabine, Carol Hall and Karyl Ketchum have presented an overview of African–American style. Although the essay includes a discussion on hip-hop, one of the most iconic representations of this culture, it places streetstyle within the historical context of the development of African–American dress from slavery onwards, and weaves in the impetus and development of dressing in particular ways by placing the concept of respect at the centre of black style motivation. Thus it maps out the line of protest that marks the history of African Americans and their place in the US through differing style systems where beauty in dress and the presentation of self are seen as resistance. Such an approach brings to the surface a string of issues that include identity and self-worth, the sense of place, and most fundamentally the question of what black style might mean.

The term 'black style' generally conjures up images of black youth and street culture. Although phenomenal in its impact on fashion and style across the world, this is not the only aspect of black life that warrants critical exposure. The book also examines everyday dress, occasional and traditional clothing. Thus black style, in this context, is an expression of the ways in which different kinds of people within the African diaspora have negotiated and defined their sense of self in spite of the legacy of inequality meted out through race and class.

Black style is also about 'an archive of black styles',[5] which includes garments and looks that resonate particular historical moments of protest and negotiation. A 'Free Angela Davis' T-shirt worn by a black female supporter in Britain expounds solidarity across the Atlantic for black civil rights, and during the late 1960s and 1970s the Afro hairstyle was seen as a symbol of black militancy. One must bear in mind that for many, the graphic image of heroes such as the African–American militant Angela Davis touched a nerve in black women (and men) beyond the US, since they empathized with her beliefs and actions. For some, clothes, accessories and hairstyles were the only means by which they could engage in political activity.[6] Added to this, the vigilant marketing of the Afro as a sign of black beauty and identity during the period has understandably left a legacy of mixed cultural messages. Angela Davis has revealed how infuriated she has become by the way her fervent involvement with the civil rights politics of the time has now been reduced to her hair and dress style of the 1970s, particularly her Afro hairstyle, which now translates from 'a

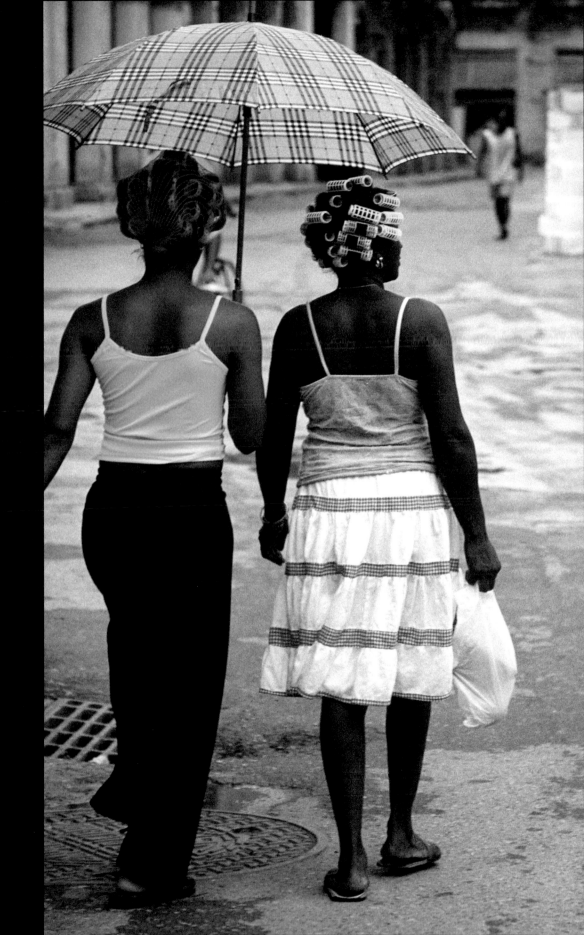

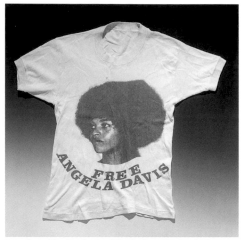

Courtesy Vanley Burke/Birmingham Central Library
© V&A Images

politics of liberation to a politics of fashion'[7] – or what she terms 'revolutionary glamour'.[8]

Ultimately, black style cannot be defined as such just because it is on the black body, although performance in terms of how an individual walks, gestures and speaks lends added cultural dimensions. It is also dependent upon the creation of the clothing: the oversized tracksuit, the flurry of froth on a child's gown, or the way the clothes are styled on the body. It is an art, and therefore part of the influential black arts practised throughout the African diaspora. As Toni Morrison has remarked, black art 'must look cool and easy. If it makes you sweat, you haven't done the work.'[9] The pictures featured in the essay 'Check It: Black Style in Britain' show that black people dress in a variety of ways: some express allegiance to specific groups or fashion trends, while others are more individualistic; nonetheless they have constructed over the decades a catalogue of garments and style details, accessories and hairstyles that have helped to define a black style aesthetic.[10]

Although the contributors have focused on the dress practice of black people in specific countries, and have teased out a wide range of issues that are primarily local or regional, they have also revealed ways in which these different cultural geographies are connected. The connection derives principally from their shared history of slavery and the immense disconnection this has caused. Each country bears the historical and cultural

ruptures that resulted in the creation of the African diaspora, notably: slavery, colonialism and imperialism, which in turn have had an impact on migration to what many believed to be their 'motherland' and 'El Dorado'. Those who stayed in colonized Africa and the Caribbean as well as those who left have experienced enormous changes in the relationships between different groups within the African diaspora.

Within countries that are predominantly black, issues such as class and local traditions exacerbate concerns around concepts of place. Carolyn Cooper discusses the social hierarchy that produces tensions within the medical system in Jamaica by looking at the way in which the wearing of dancehall styles by women in the hospital environment leads to conflict with hospital staff. Part of the relationship between uniformed professionals and their patients revolves round the question of decency and the medical establishment's attempts to enforce a dress code within the hospital. Local cultural issues also dominate John Picton's analysis of the textile industry in West Africa, in which he traces the emergence of a national tradition in the use of local textiles. Within this cultural act specific local associations are expressed by the particular structure, pattern and colour of cloth, and these acquire additional significance when lengths of cloth are sewn together and wrapped around the body. In outlining the cultural and personal impact of textile production and the wearing of

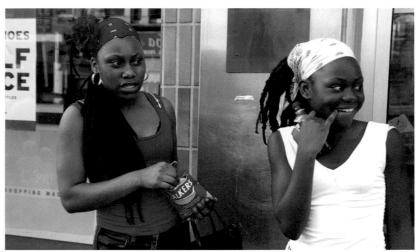

London, 2003 © lydiaevans.com

cloth, Picton conveys the importance of traditional textiles and regional dress in providing West Africans with constant reassurance of their sense of self. Identity is thus another contentious term within current thinking about black visual culture. *Black Style* proposes that the issue of identity needs to be discussed within the context of broader cultural identities, in order to chart the relevance of dress and the styling of the black body in the development of an African diaspora aesthetic. Stuart Hall has stated that there are two ways of thinking about cultural identity. First of all, there is the 'one true self' where the similarities between people of the African diaspora highlight the 'common historical experience and shared cultural code which present us as "one people"'; and secondly there is the 'deep significant difference which constitutes "what we really are" '.[11] *Black Style* explores both of these interlocking modes of self-definition, which inevitably place the black styled bodies of women, men and children in the cultivation of an African diaspora aesthetic. A by-product of this is the potential of dress to articulate the emotions and desires of black people. The debate must necessarily extend beyond simple notions of identity and 'identification' to allow for 'the struggle to take positions which may not be final, rather than the fixed positions of "identity politics"'[12], in order to consider the dignity of dress as an agent of self-respect and human dignity. Such issues are particularly poignant considerations in the current polemic about asylum seekers and refugees referenced in Carol Tulloch's

essay. The personal and geographical disruption they experience on entering profoundly different cultures, such as Britain, compounds their dependence on maintaining a sense of self and dignity to survive. This can be achieved partly through dress, in the cultural meaning newcomers invest in the clothes they have brought with them as a reminder of their home culture, as well as how they decide to dress in their new country. Whatever their choice, a sense of self and dignity is mapped on to a body that has endured cultural dislocation to confront a new way of being. [13]

The concept of dignity can work on various fronts. It can be the acknowledgement and cultivation of dignity in oneself as a quality of self-worth and value; it can engender respect from others, thereby causing them to acknowledge human dignity and respect it in others (in essence, yielding respect); whilst 'Human Dignity' can be maintained against the force of outside powers that threaten an individual. Alternatively, 'dignity as a quality' is something individuals develop for themselves. [14] In keeping with this aspect of dignity, the African-American scholar and activist W.E.B. Dubois believed that individuals who do not protest against injustice are likely to lose their sense of dignity. Indeed, Bernard Boxhill argues that it is an individual's right to 'protest their wrongs … to show self-respect and to know themselves as self-respecting'. [15] Overall, human dignity is an 'outward manifestation in how she [he] presents herself [himself] to others. The struggle

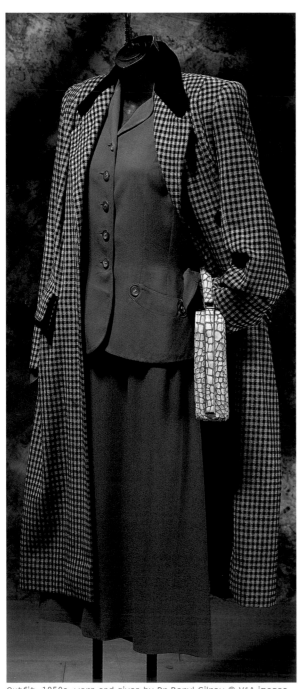

Outfit, 1950s, worn and given by Dr Beryl Gilroy © V&A images

of oppressed people for dignity can be the struggle to be seen as what they are: persons equal to their oppressors. And the quality of dignity — responding to injustice in ways that make clear that we know we are persons, even if you refuse to acknowledge this — can be a tool in that struggle.'[16]

The essays by Kaiser *et al.* and Tulloch are driven by such issues. The writers urge readers to look beyond the generalizations and stereotypes projected on to black style by others outside the culture, marking it as being less worthy of recognition and respect as far back as slavery (not all black men who wear very low slung baggy jeans are potential criminals) and to consider how dress is used by black people as an individualized or group dialogue with society. The influences are myriad, the reasons likewise. A further aim of this book is to prevent the reduction of black style to 'essential stereotypes'[17], and to advance a more plural perspective of black style. What is exciting is that there is always a new order, new ways of 'being black', to help people retain a sense of dignity and self-worth.

A background beat to the book and the exhibition is black music. Music shapes all aspects of black life as a soundtrack to its identity, particularly when that identity has to be clarified in a space that categorizes black people as different. Music can provide the means to bring people together as well as to diffuse racial tension, as in such music genres as Two Tone and UK Garage. The use

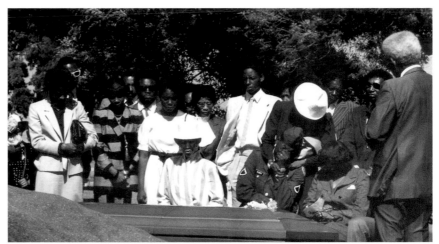

Los Angeles, 1980s © Syd Shelton

of music by different cultural groups to help define them has a secondary impact – it allows others to see them 'from the inside'. [18] Music was the source that enabled African Americans, for example, to create what Mark Anthony Neal has termed the 'Black Public Sphere'. [19] Following slavery, and during the period of reconstruction, African Americans established a range of spaces where they could be visible with ease. These were notably the black church and pleasure houses such as jook joints [20], fiercely contrasting venues but with unique ways of resolutely embedding into 'black expressive culture' that which was apposite to the white American public sphere. [21] This situation still exists across the African diaspora. Neal cites gospel and popular music, and dance as examples. But what of the individuals who attended these places and helped to make them into the black cultural signifiers they have become? Their modes of dress actually served to strengthen their cultural definition (see, for example, pages 102–3 in the chapter 'Check It'). Therefore, music offers escapism and reality. When married with the associated styles of dress by those listening to or performing the music, then the particular black cultural experience is complete. By dressing their bodies in ways that affirm the cultural articulations meted out by black music, they create a heady and effective combination. Thus the styled black body can be considered as 'emotion as form' [22], thereby perpetuating the idea of the black body as a quintessential object as sign. [23]

The occasion of death in black cultures raises a number of issues to do with dignity, identity and respect, prompted by the question of the appropriateness of dress. The end of a life is not the end of relationships; rather: 'At death identity is altered not only from the loss of figures who have served as sources of identity, but also by the new responsibilities which the living must take upon themselves.' [24] Carolyn Cooper has raised the issue of what middle-class Jamaicans believe to be the 'correct' image mourners should project at funerals, documenting their fierce objections to the wearing of dancehall clothing, which they see as an offensive act. In comparison with the funerary rites that still prevail in the West, there has long been a move away from the traditional excessive wearing of black garments to something that is akin to 'choreographing their own steps ... The mourner's dance is changing, but it persists.' [25] Studies focusing on this issue have found that conspicuous dress could be read as a subversion of the rites of death, as well as the celebration of the life of the deceased, allowing 'the spirit to see that it is properly mourned for'. [26] Indeed, recent academic reassessments of funerary practices reveal 'the level of ostentation and variety in nineteenth-century funerary culture suggests that mourning was not a therapeutic practice of assuaging grief, but an expressive practice from which highly individual and personal feelings were constructed and demonstrated. Moral argument is thus somewhat redundant.' [27]

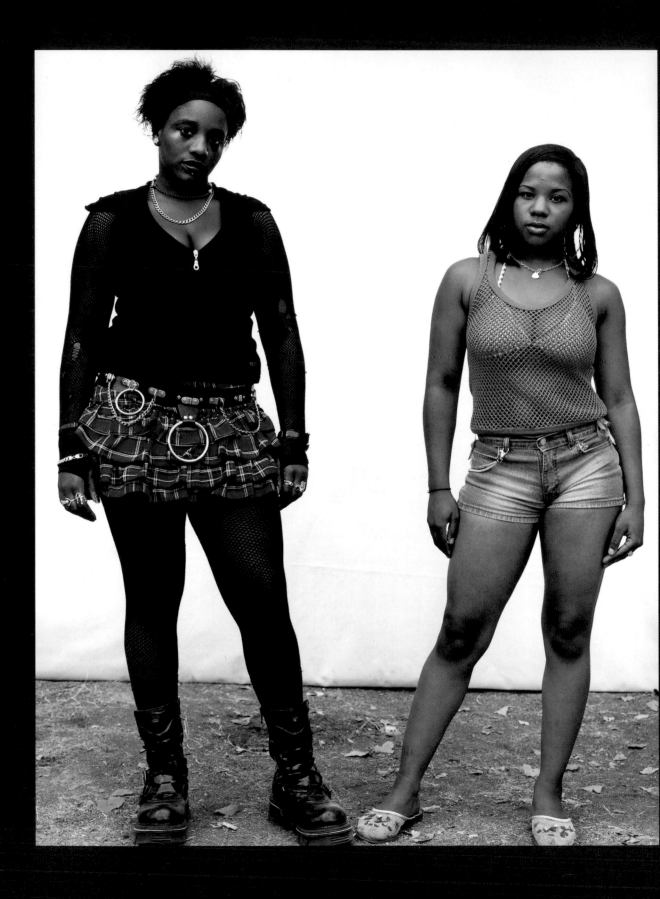

In support of Cooper's discussion on 'appropriate' funeral dress, John Picton forwarded to me, just days before the completion of this introduction, an excerpt of a letter from a friend in Lagos. It describes the funerary rites of an elderly woman of Nigerian and Ghanaian ancestry. Picton felt it was important to present it here as an example of what he sees as 'the enactment of a social drama in an elite family, complex in its interplay of identities, textiles and religious practice'.[28] The celebration of the life and death of the 'grand lady "Mama"' was met with the appropriate level of respect and dignity expressed through her own and her mourners' bodies. The quote that follows is an appropriate summary of the concerns of this book:

The room where she lay in state was decorated with a profusion of [real] flowers ... An old Ghanaian lady put into the coffin money for Mama to pay the boatman to carry her across the river as well as powder and perfume for her to freshen up after the journey and two lengths of new *ankara*[29] ... Hundreds of guests came and went from 1.30 p.m. until after midnight. They were ALL fed and watered and departed with a souvenir of Mama's life and death. 600 people bought six-yard pieces of *ankara* for *aso ebi* worn at the reception [that followed the burial] by both men and women. It was fascinating to see the variety of styles, many embellished with embroidery.[30]

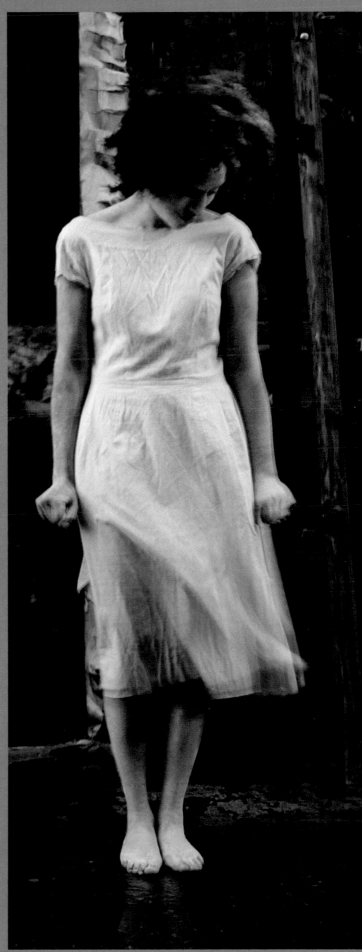

Martina Topley Bird, 2003 © Yacht Associates

WHAT TO WEAR IN WEST AFRICA:
TEXTILE DESIGN, DRESS AND SELF-REPRESENTATION

JOHN PICTON

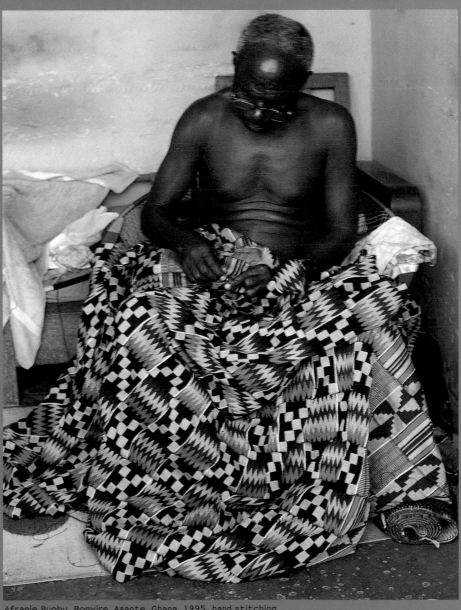

Afranie Buobu, Bonwire, Asante, Ghana, 1995, hand stitching
strips of cloth woven of cotton and rayon/viscose. The pattern
is often called 'Madam Fathia' and is named after the Egyptian
wife of Kwame Nkrumah, the first President of independent
Ghana, who popularized the wearing of locally woven cloth as a
celebration of national identity. Photo by John Picton

Just imagine the following scene ... the post-office ... Upon arrival at the head of the queue, you present your letters to her ... Her face is a perfect mask of cosmetic colours: navy blue eyeliner, burgundy eye shadow highlighted with copper, and dark red lipstick ... She adjusts her robe so that it sits perfectly balanced on her shoulders. The whole chest area of her dress is embroidered with multi-coloured arabesques. The dark green, navy and gold colours complement the royal blue cloth ... You know that your letter will arrive on time, but you still wonder how such women can juggle their small salaries with their social and sartorial needs.[1]

This essay is about the relationship between textile design and dress in West Africa; or rather, the relationships between the many things that come to bear upon it: pattern, texture, colour, social event, local and trans-continental histories, gender, ethnicity, nationality, dress and tailoring. It also touches upon the significance of West African textiles and dress within the context of the Black and African fashion presence and aesthetic around the world.

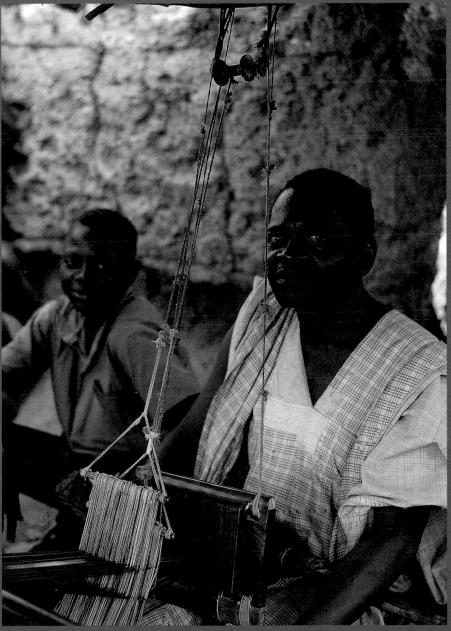

Amusa Ayinde, a weaver, Oyo, Nigeria, 1971. He sits at his loom wearing a wide-sleeved gown of printed cotton. Photo by John Picton

FROM TEXTILE HISTORY TO THE POLITICS OF FASHION

For more than a thousand years, West Africa has been one of the world's great cotton-, indigo- and textile-producing regions. [2] What you see nowadays in the clothes people are wearing and in the heaps of textiles for sale in the markets is an eclectic mix of local and imported elements; but this is nothing new. There have long been spinners, dyers, weavers, embroiderers and tailors supporting local production, as there have networks of trade. Historically, there are two sources of imported yarns, dyes, fabrics and garments. One is North Africa and the Middle East, mediated by trans-Saharan trade and by the popular spread of Islam, and the other is Europe, through coastal trade beginning in the sixteenth century. Since then, successive diasporas, initiated by transatlantic slavery, have implanted African forms and sensibilities into European and American culture.

In the mid-nineteenth century, slavery gave way to colonialism. Some traditions of visual practice dating back to an earlier time (for example, dress, textiles and masquerade) have survived, flourished and developed. Others (wood sculpture, for instance) are at best obsolescent, making way for new practices such as photography, easel painting, public sculpture, printmaking and the factory-printing of cloth. As transatlantic slavery came to an end, there grew up in the coastal cities an elite intellectual class of West African people, professionally trained in European universities. They provided leadership to the resistance to colonial rule as it then began to develop; they initiated the documentation of local traditions; and they recognized the need to define both national and ethnic identities for the modern world they were helping to create.

Dress sometimes played its part in these processes. For example, in nineteenth-century Lagos the questions of what to wear and what to call oneself were part of the anti-colonial politics of the time. Some people chose to reject the European names they had been given in childhood, as the children of freed slaves repatriated from Sierra Leone, in favour of Yoruba names. Men discarded European dress for the wide-sleeved gown, and women likewise for the wrap-around skirt, giving rise to what would subsequently become known in Nigeria as 'national dress'. In the mid-twentieth century, in what is now Ghana, its first president, Kwame Nkrumah, also emphasized the nationalist significance of returning to local dress. In both countries, as throughout the region, the politics of what to wear has ensured the continued flourishing and evolution of local dress and textile forms, these also informing (but without dominating) local fashion industries. Thus, in Senegal, for example:

> Fashion ... is an ironic phenomenon of expansion and instability, the intensification and undermining of inequality, local cultural autonomy, and global economic dependence. Dakar's couturiers, the most diverse and renowned on the continent, are fabricating an African modernity that addresses the hybridities, contradictions and aspirations of the post-colonial condition ...' [3]

In 1998 the *Revue Noire* listed more than 60 designers in 15 African countries, including all but four of the countries of West Africa. Some now work in Paris or London, and others in the US, but most have established practices in their particular countries:

'Fashion is a frontier of struggle among colonial civilising projects, African self-representation, local power contests and the collective shaping of specific modernities.' [4]

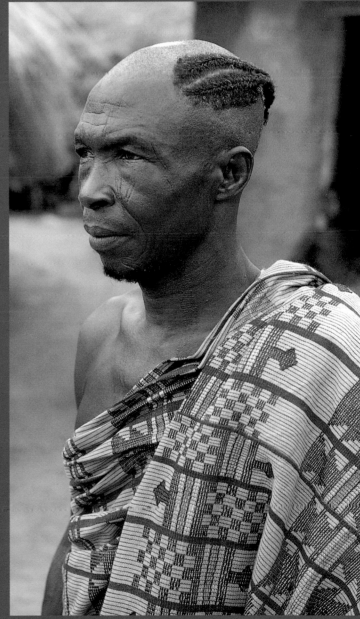

Cotton cloth woven on the women's upright broadloom, Ebira, Nigeria, 1967. The design imitates the narrow strip and weft-float format of *aso oke*. The unshaven and plaited areas of its wearer's head mark the place where magical medicines have been placed. Photo by John Picton

TEXTILE DESIGN AND AESTHETIC VALUE

West Africa is a complex social and historical entity, and any summary account must point up the illusion of a seemingly unified presentation of its subject. Rather, there are many histories in which the traditions of a given locality have become engaged with forms and fabrics introduced from elsewhere. There are continuities of form, practice and idea maintained from one place to another, but whether these amount to a common set of values is another matter altogether. There is, for example, nothing specifically African about an eclectic mix, but there are specifically African versions of it in all those histories. Similarly, there is nothing specifically African about taking obvious delight in breaking up a plain surface, but it is the most noticeable feature of West African textile design, and there are specifically African forms. Some of these depend upon a particular inheritance of the technical means available locally for the manufacture of a piece of cloth.

A textile is an odd sort of thing when considered in respect of its design or patterning in West Africa, where it continues to be both normal and commonplace for cloth to be woven in a long narrow strip often no more than about 10 centimetres (4 inches) wide. Once the desired length is complete, it will be cut into pieces and sewn together edge-to-edge. It is only then that the visual effects intended by the weaver can be seen, manifesting a specific arithmetic in the precise counting of warps and wefts, and geometry in the layout of pattern, that weavers must learn, and learn how to develop if a given tradition is to flourish.

Patterning is most commonly of three kinds. The first is warp striping, achieved simply by using different colours of warp yarn in the

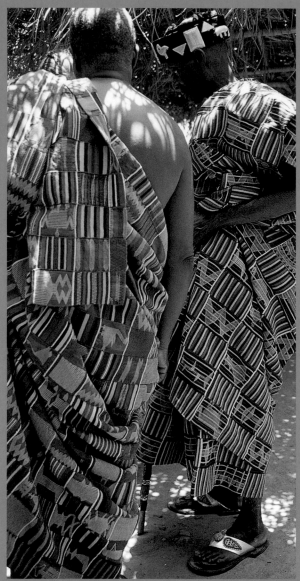

Elders conferring at the coming-of-age rite of some young women, Afegame, Volta district, Ghana, 1999. They wear narrow-strip cotton cloth elaborately patterned with weft-float and weft-faced designs. Photo by John Picton

A weft-float design emerging on a loom at the house of Sylvanus Akakpo, Kpetoe, Volta region, Ghana, 1999. Photo by John Picton

preparation of the loom. This also means that the same pattern can be repeated across the face of the cloth or two or more sequences of stripes can be placed next to each other; and the visual effects can sometimes dazzle the eyes as if the colours were dancing. The second type of patterning is made by spreading the warp elements apart as the loom is set up so that, in the woven cloth, the warps are hidden by the weft. It thus becomes possible to create blocks of colour that can be aligned across the cloth, alternated to produce a chessboard effect, or arranged to create a seemingly random scattering of colour. The third type of pattern requires an additional or supplementary weft that 'floats' across the warps. [5]

Particular ethnic and regional traditions are characterized by the way in which these techniques are used. Warp stripes are the most commonplace, sometimes with supplementary floating weft patterns. One of the best examples is the Yoruba cloth known as *aso oke*, literally 'top-of-the-hill cloth', the hill being the location of the tradition received from one's ancestors. Weft-faced patterns are especially associated with Mali and Sierra Leone. Only the Asante and Ewe, in Ghana, bring all three weave structures together in one strip of fabric, thereby creating forms that are impossible to replicate exactly on a European broadloom. The narrower loom facilitates these design processes by allowing very different patterns to be placed beside each other in the one cloth. This may in the end be the justification for the continuing florescence of these traditions.

Delight in breaking up a plain surface, illustrated in a thousand different ways by West African weaving, is also evident in resist-dyeing. In the western Yoruba city of Abeokuta, founded in the 1830s, two forms of the indigo-dyed cloths known as *adire* developed with the advent of factory-woven cotton shirting. In one, raffia fibre was used to stitch or tie a pattern across the length and breadth of the cloth, while in the other starch was pasted in a repeat pattern through cut metal stencils. Both the raffia and the starch resisted the dye to create the patterned surface. The manner in which the patterns developed was conditioned by the quality of the factory-woven fabric, which was finer than a textile woven of hand-spun cotton. Moreover, although indigo-dyed yarn was a commonplace element in weaving, locally woven cloths would only be resist-dyed if they were old and worn and in need of toughening up; and a few sticks or stones might have been stitched into the cloth (this providing the origin of the raffia-tied *adire*). The starch-pasted method almost certainly was adapted from European packaging, the zinc linings of colonial tea chests being originally used to make the stencils. In another Yoruba city, Ibadan, also founded in the 1830s, comparable designs were painted freehand, again using starch. There is also now some suggestion that while the imperative to pattern, along with the raffia-resist method, has its origins in local sensibilities and practices, at least some aspects of these developments were influenced by freed slaves repatriated from Sierra Leone. [6]

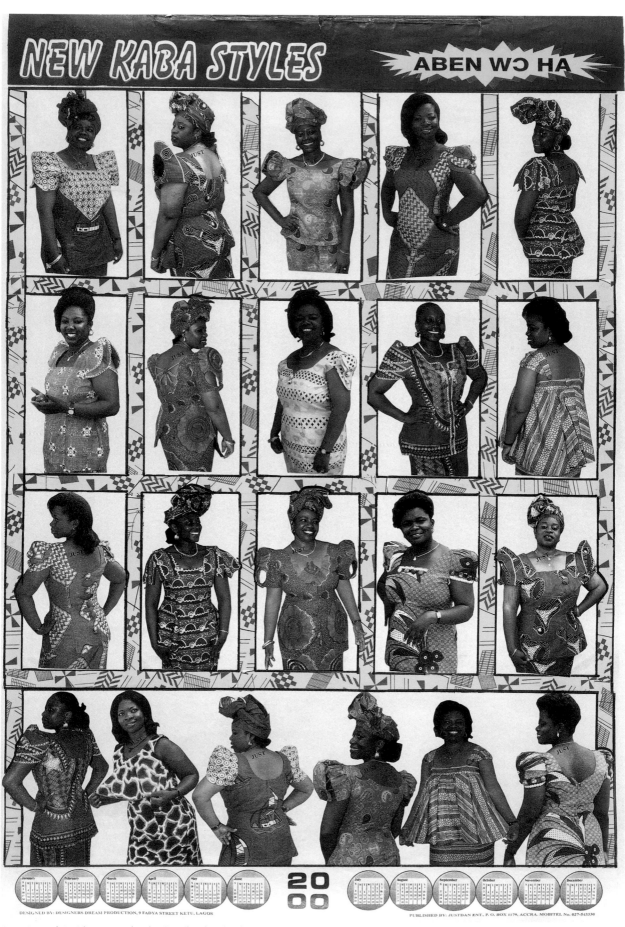

A poster printed in Lagos, Nigeria, for distribution in Ghana, 1999, and showing some of the latest 'up and down' Ghanaian styles, collection John and Sue Picton.

The earliest dated example of a 'Dutch wax' cloth, produced for trade in West Africa by the Haarlem Cotton Company, 1895; collection ABC, Hyde, Cheshire. The design shows the twelve pennies of the English shilling, and is still known in Ghana as 'the palm of the hand is sweeter that the back of the hand'.
Photo by John Picton

Long-running trade and family contacts between Lagos and Freetown may also have been the source for a new set of resist-dyeing techniques that arrived in Nigeria in the late 1960s. They quickly acquired the name *kampala* after a well-reported peace conference there. *Kampala* techniques include folding and tying, stitching, the use of melted candle wax as a resist agent, and the application of factory-made dyes. These and other techniques are not only found in Freetown, but also in Bamako (Mali), St Louis (Senegal), and indeed all over West Africa. Meanwhile, the popularity of *kampala* signalled the decline of *adire* in Nigeria. There has been a limited measure of revival, mainly through the work of textiles artist Nike Olaniyi at her art centre in Oshogbo (see p.41); but otherwise the decline generally persists.

In contrast, in the Malian Bamana technique known as *bogolan*, the cloth is dyed yellow, designs painted in iron-rich earth to darken it, and then the yellow bleached out in the unpainted areas. Originally for the magical protection of hunters, and also young women undergoing initiation into adult status, this technique has evolved in recent years to create a modern fashion fabric in Mali.[7] It is widely available, and imitated in Europe and the US; it is also a means of picture-making. [8]

We can see this same celebration of pattern in the bright, almost blatant, African-print fabrics now so ubiquitous throughout Africa, Europe and the Americas. Indeed, this is a proposition that is supported by what we know of their history. In the course of the nineteenth century Dutch textile

manufacturers wanted to find a cheaper way of replicating the Indonesian wax batik process, to undercut Indonesian production. In due course they developed a duplex roller system that printed hot resin, rather than wax, on both faces of the cloth. Additional colours were hand-blocked on once the resin was cleaned off. However, the finished cloths had a variegated quality that Indonesians did not like; and yet, when, by chance, Dutch merchants, probably in Elmina (precise details remain unknown), tried these fabrics on their customers they proved to be extremely popular. Once the sights of the designers in the Netherlands were trained upon this region of West Africa they quickly learned that the illustration of local proverbs added to the interest in these fabrics. The earliest dated example, produced by the Haarlem Cotton Company but now in the ABC (Arnold Brunnschweiler and Co.) factory archive at Hyde, Cheshire, was made in 1895. It shows the palm of the hand with the twelve pennies of the English shilling; for 'the palm of the hand is sweeter than the back of the hand' – the point being that as the palm holds the money so we hope to receive good fortune. [9]

Variegated design and the visualization of proverbs seem to have secured the initial success of these cloths; for the depiction of proverbs was, and continues to be a significant aspect of the visual culture of Twi-speaking peoples; it features in woven textiles of the Asante [10], and also in *adinkra*. As to the variegation, one of the designers in the ABC factory at Hyde told me that it 'makes the cloth

sparkle'. This leads us to another feature of dress and textile design in West Africa, a concern with shininess, a property that is about the enhanced visibility of a thing that glistens. 'Mirror in the sun' is the title of a popular Nigerian television soap opera, a current Nigerian hair style, and some of the textile patterns using the laminated plastic fibre known as Lurex. Shininess may also be about the apotropaic magical properties of shiny things to reflect evil back upon its source.

In the pre-industrial technologies of West Africa, printed textiles were unknown but for *adinkra*, an Asante cotton cloth produced at Ntonso, north of Kumasi, in which graphic signs are printed in black, using stamps made from carved calabash (gourd). Almost all the individual patterns have an associated proverb, but this has not prevented the creation of novel patterns that are based on the Mercedes-Benz logo, or that make use of writing. These cloths do not convey precise messages, but evoke a tradition of knowledge about the social world. When the designs are printed on red, black, brown or purple, *adinkra* is worn at funerals, whereas on white it is celebratory.

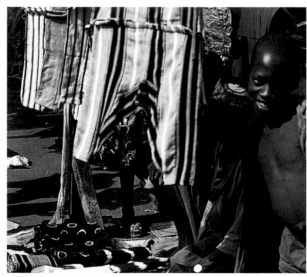

Cotton and indigo-dyed cloth for sale in Ougadougou market, Burkina Faso, 1971. Photo by John Picton

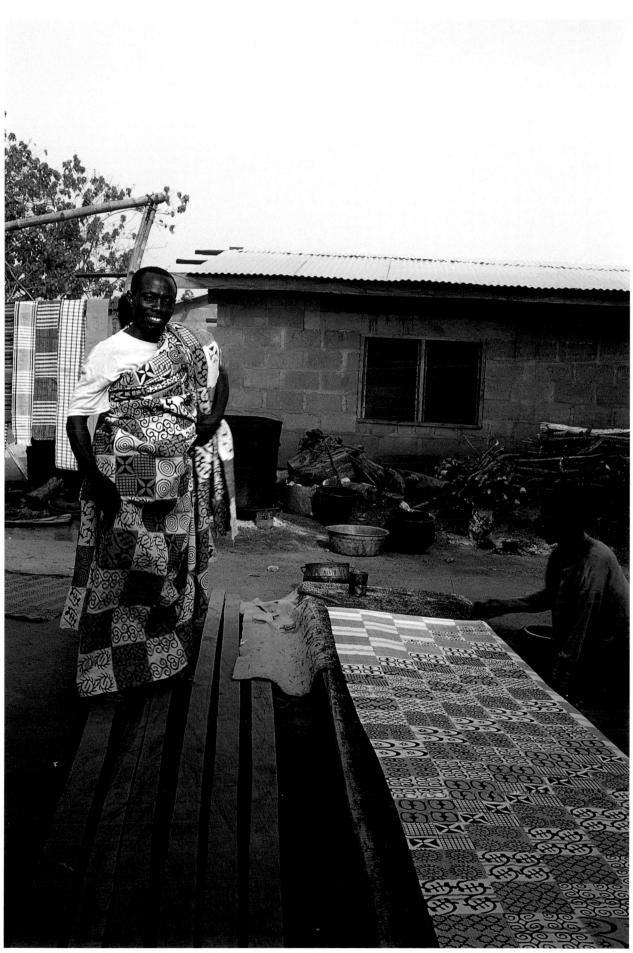

Printing adinkra, at Ntonso, north of Kumasi, Ghana, 1999. Someone
models the cloth at left to show how it is worn. Photo by John Picton

TEXTILE
AND DRESS

Perhaps the most obvious point about indigenous dress forms is that they make maximum use of the cloth available. This allows a larger person to move, and to dance, with greater elegance than someone who is slight – an elegance created by the movement of the cloth. [11] By contrast, close-fitting garments can look most inelegant in movement. Of course, you see European clothes, made up of differently shaped pieces of fabric, cut up and stitched together, throughout West Africa. Yet African people have so many other ways of using cloth in dress: a locally woven cloth would never be cut up into such small pieces except in modern fashion design.

Until about 50 years ago, women in most parts of West Africa would wear two wraparound skirts, a smaller underskirt around the waist beneath a larger cloth wrapped around above the breasts when visitors called or when going out, or below the breasts if working at home. Two more lengths of cloth would complete the ensemble, one to tie the baby on her back, and the other worn around her head. Elite Asante women, however, also wore a cloth around their shoulders as a mark of status. The blouse, now effectively universal throughout the region, was a nineteenth-century addition coming via Christian missionary activity, no matter how thoroughly 'traditional' it might now seem. It has led, of course, to the ensemble sometimes known as 'up-and-down', which can take a seemingly infinite variety of forms – Ghanaian women, for example, take delight in elaborate sleeves and shoulders. [12] However, in Mali and Senegal women also wear the wide-sleeved gown, the *boubou*, 'once the dress of powerful men, marabouts and princes'. [13]

Elsewhere in West Africa the wide-sleeved gown (the Hausa *riga*, and Yoruba *agbada*) remains the more-or-less exclusive dress of a man; and even in Mali and Senegal there are subtle differences between the gowns for men and for women. [14] Indeed, for men from Senegal through Mali to Nigeria and Cameroun, it seems to have been one of a three-garment matching set, together with an under-tunic and (sometimes very baggy) trousers, possibly with its origins in Saharan camel-riding dress. Locally woven cloth would certainly be used for the more expensive and prestigious sets; but the forms were relatively simple yet ample, using as much of the cloth as possible.[15] The under-tunic can, of course, be worn without the gown, and is now often part of a two-piece set with matching trousers. [16] Sometimes it has also been a vehicle for wearing protective amulets, either texts from the Qur'an [17] or magical medicines. [18] It can also be made of cloth with inherently protective design forms, as in the case of Malian *bogolan*. [19] A cap of some kind, perhaps hand-embroidered, always rimless (though sometimes with 'ears'), completes the ensemble.

Though commonplace across the savannas, the wide-sleeved gown was adopted by Yoruba people probably only in the course of the nineteenth century, in response both to colonial rule and to conversion to Islam. Prior to that, and in common with other peoples from the area to the west of the lower Niger kingdom of Benin (not the modern republic, which has simply

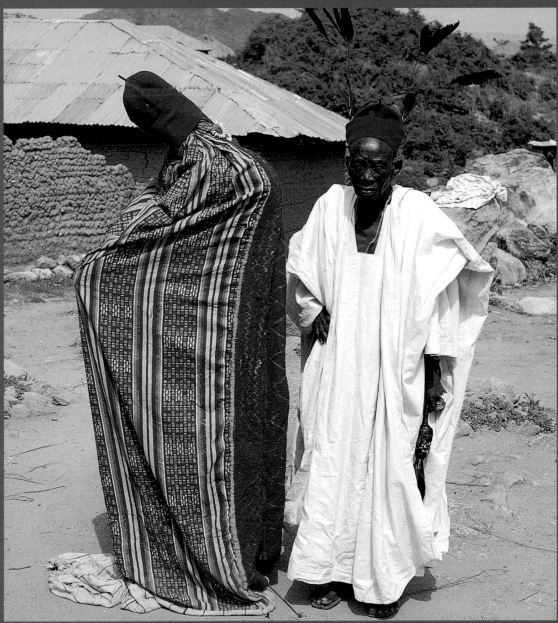

Adeika Onoko, a lineage chief, Kuroko, Ebira, Nigeria, 1967. He
wears a white cotton wide-sleeved gown and tunic, a red felt cap
with Nightjar breeding plumes, and in his left hand carries a magic
buffalo tail. Beside him stands the re-embodied ancestor that
led him through his rite of installation. Photo by John Picton

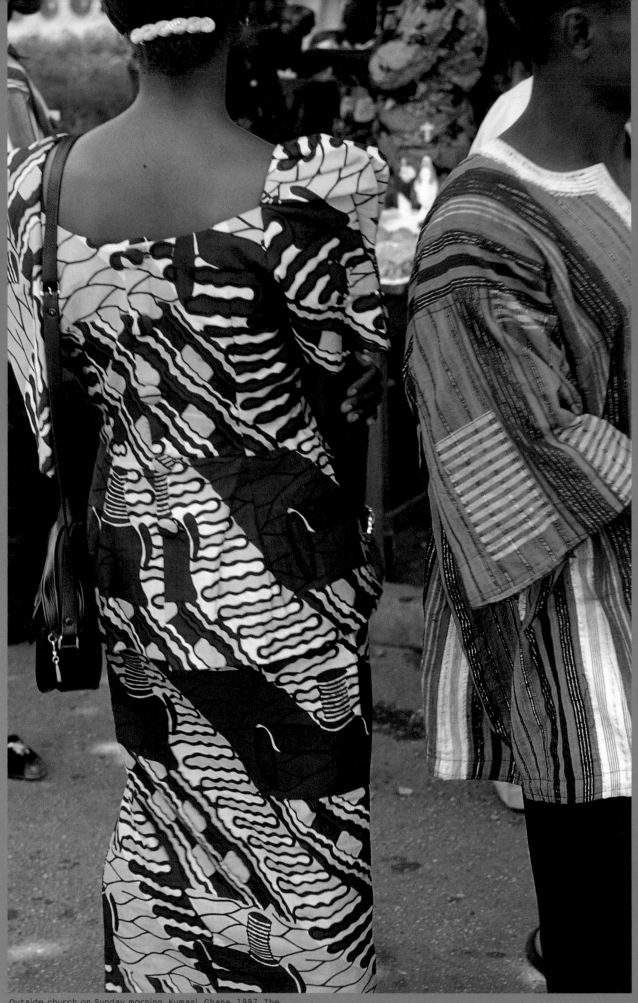

Outside church on Sunday morning, Kumasi, Ghana, 1997. The young woman wears a *kaba* (also known as 'up and down') made of 'Dutch wax' with a sewing machine design. The man at right wears a tunic of narrow-strip cloth woven of cotton and lurex in the Volta region. Photo by John Picton

borrowed the name) and at least as far as the Akan or Twi-speaking peoples of Ghana and Ivory Coast, a man draped a large cloth over the left shoulder, and under the right. In the dress traditions of the lower Niger region from the Benin kingdom eastwards, a man wears a wrap-around skirt; and even the elaborate court dress worn by the king and the nobility of Benin City is an elaborated version of this. Sometimes a long shirt (derived from the European nightshirt) is worn over this.

It should by now be obvious that once a cloth is wrapped or draped around the body, the full effects of its design are necessarily obscured, perhaps even denied, in spite of the attention given to the creation of pattern. Although it is not obvious how or why, clearly pattern does matter, for the repertoires of weavers, dyers and factory-based designers continue to evolve within particular traditions of textile and dress design, distinctively from one centre to another, incorporating new fibres, textures and colours.

COLOUR,
TEXTURE
AND TRADE

With so much variety in local traditions, we might ask why imported cloth was a well-established West African preference long before coastal trade with Europe. From the outset European traders had always included linen and woollen textiles amongst their goods. Some, in particular the Portuguese, traded local textiles from one part of the West African coast to another. They also captured weavers and put them to work as slaves on the Cape Verde Islands to make cloth with North African designs for the coastal trade. On the other hand, Danish merchants in the early eighteenth century were surprised to discover that Asante weavers unravelled the silk cloths they had obtained from them in order to reweave the yarn to local design specifications. Their shininess and well-saturated colours, although quite different from anything available locally, were perceived as effective within a local aesthetic. The local wild silk produced a less shiny greyish yarn that was prestigious in some traditions but not in others. Local cotton grew in at least two colours, white and beige, while indigo was universally available throughout West Africa, together with other vegetable and mineral dyes that could produce various shades of blue, yellow (and therefore green if these two were used one after the other), brown, black and a weak, purplish pink. A well-saturated red was not available, however; and yet red was almost everywhere a colour of ritual value, albeit locally specific. As soon as red woollen cloth and cotton yarn were available, they were in demand. Similarly in the nineteenth century, the waste from Italian magenta-dyed silk weaving was traded across the Sahara to be re-spun for local weaving.

Textile shops, Kumasi market, selling current locally-printed versions of 'Dutch wax' cotton cloth, 1995.
Photo by John Picton

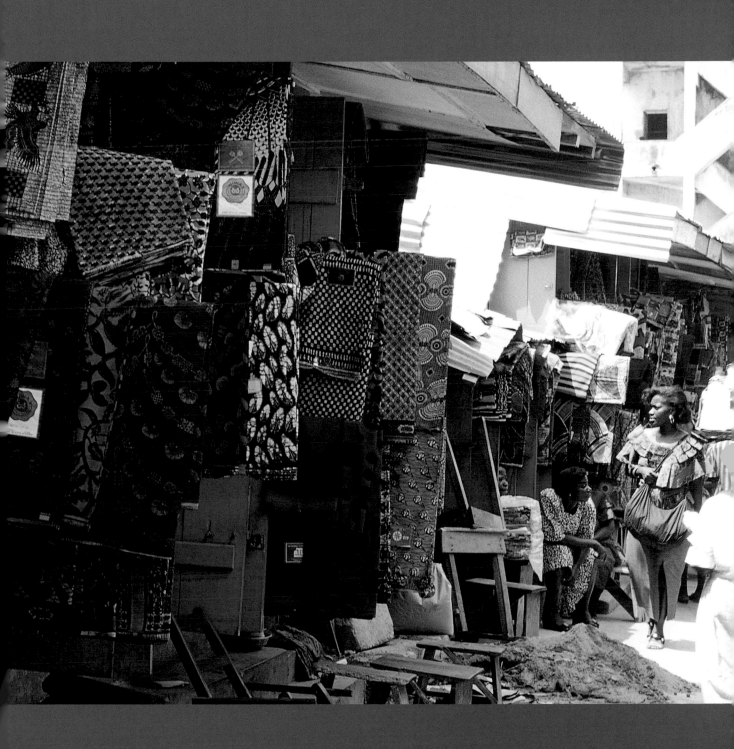

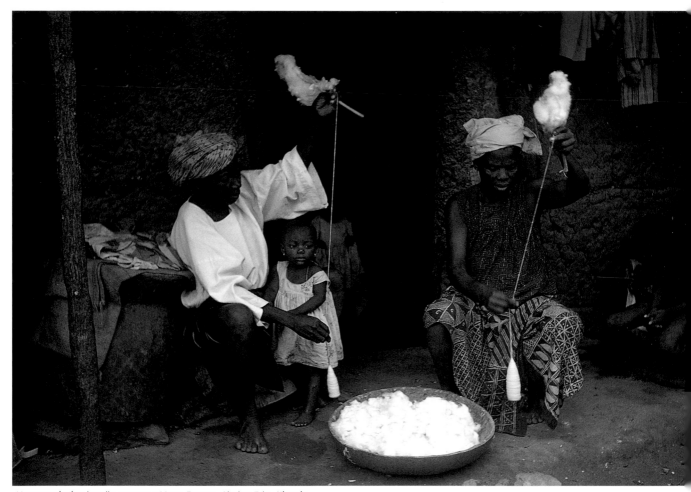

Women spinning locally grown cotton, Igarra, Akoko-Edo, Nigeria, 1969. The woman at right wears a wraparound skirt of *adire* cloth (indigo resist-dyed in Abeokuta). Photo by Sue Picton

In the late nineteenth century, silk was replaced by rayon and in due course by other artificial fibres, while ready-dyed cotton yarn assumed a substantial place in colonial trading accounts. The greater intensity and variety of colour achieved with modern dyes was one advantage, while the finer quality of machine-spun yarn was another. In a part of the world where

imported silk (and its successors); to these one can add a bast (or linen-type) fibre; and from the 1970s onwards a laminated plastic fibre with a metallic core in all colours of the rainbow and more. To these, again, one can add the permutations of weave structure; and the wide range of possibilities open to a weaver even within one tradition. The fact that a cloth is multi-textured and patterned is often more significant than precisely what the patterns, colours and textures are. That being so, one can easily see why the details of a textile pattern are rarely the focus of care or attention once the cloth is draped around the body. The point is that the cloth does not need to be seen in full, for the fact that it is patterned remains obvious. Yet even then, the notion of the draped fabric may entail its own local aesthetic, and the fact that the design is never fully visible may in itself provide another allusive property. There are patterns that do matter, of course, such as those printed on *adinkra*. These are not significant in some language-like manner, however, but as the reiteration of an inheritance of ideas and a memory of past events that is very specific to a given location.

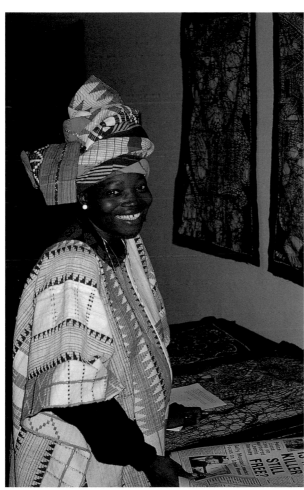

Nigerian textile artist Nike Olaniyi, wearing *aso oke*, Africa Centre, London, 1985. Photo by John Picton

conspicuous consumption was particularly manifested in the cloth you wore, the colonial and post-colonial democratization of systems of authority generated an increase in demand, giving machine-spun yarn an obvious advantage.

The catalogue of available textures in West Africa is thus impressive: hand-spun cotton, machine-spun cotton, wild silk,

DIASPORIC IMPLICATIONS

The late Black British MP, Bernie Grant, was in the habit of dressing in a Yoruba version of the wide-sleeved gown and its associated garments for the state opening of Parliament. There are retail outlets in the USA selling these clothes both to expatriate Nigerians and to African Americans, while *bogolan*, both genuine and imitation, can be found for sale in New York's 116th Street market. It must be recognized that in the diasporas of slavery the tendency historically has been to take on the dress of the place one found oneself in, and, as necessary, to use it in the process of subversion from within. However, in the formation of later economic diasporas, while dress traditions from West Africa have helped to maintain an expatriate cultural identity, they have also opened up and expanded the sartorial possibilites for the descendants of slavery. This can be seen in the case of Bernie Grant; just as in nineteenth-century Lagos a repatriated West African diaspora reinvented itself within the politics of resistance to colonial rule.

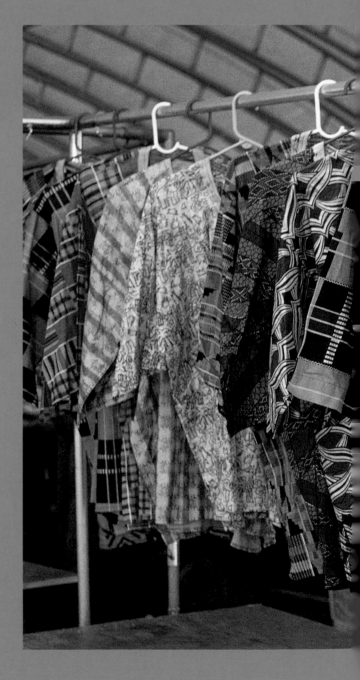

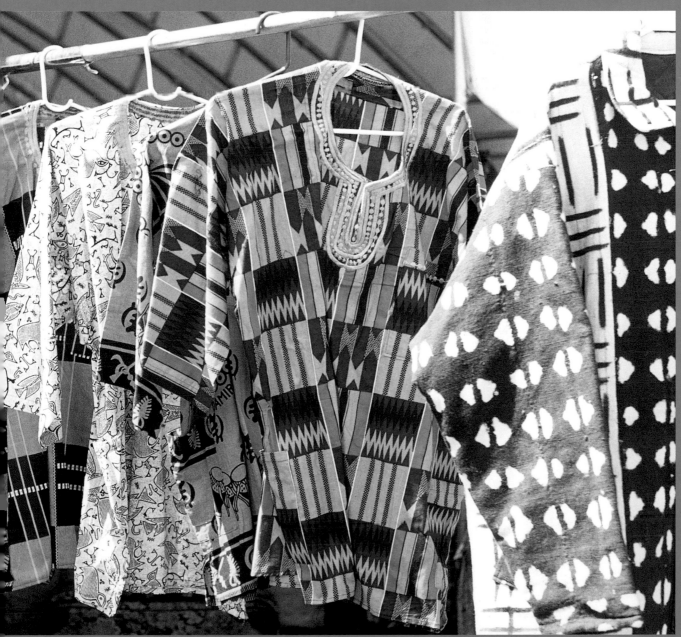

Shirts mostly of factory-printed cotton cloth on sale in a street market at 116th Street, Manhattan, New York, 1995. The patterns imitate several different West African traditions. Photo by John Picton

IN CONCLUSION, 'THE CLOTH MUST FLOW WELL'

I bring this discussion to an end with a passage so evocative of the multiplicity of questions addressed herein, evocative too of all those matters in the politics of dress among formerly colonized peoples, that it needs no further comment. Writing about kinaesthesia (the sense of movement, especially as a means of knowing one's social world) among the Anlo, an Ewe-speaking community of south-east Ghana, Kathryn Linn Geurts transcribes an interview with a weaver in which he talks about the significance of wearing locally woven cloth:

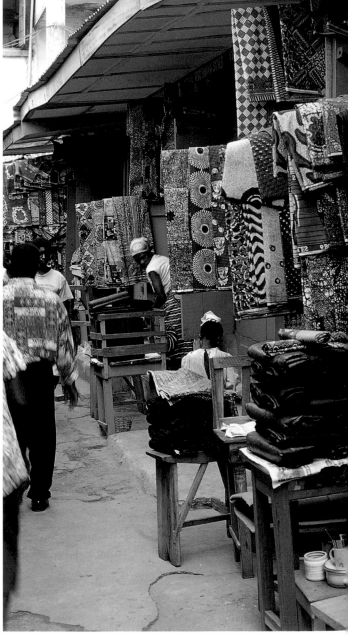

Textile shops, Kumasi market, 1995. Photo by John Picton

… the cloth must flow well to wear it, it cannot be stiff … they want it to feel smooth and soft … good cloth moves with the person, it catches the sunlight … it makes people feel proud of our past. They remember their forefathers, their ancestors, where they came from. It's not really easy to wear this cloth … You have to stand upright, you have to assume a dignity to keep it from falling off … this cloth makes you feel that you belong to Anlo. It's very different than wearing a suit and tie …

A suit is tight and makes you feel stiff. But this cloth, well, it flows around me as I walk. But then at the same time I have to keep checking on it, pay attention to it, adjust it on my shoulder [this is, of course, a length of fabric as worn over the left shoulder but under the right arm], and that keeps reminding me of, well, it makes me know I'm not a Frenchman, at all, or an Englishman. It's African.[20]

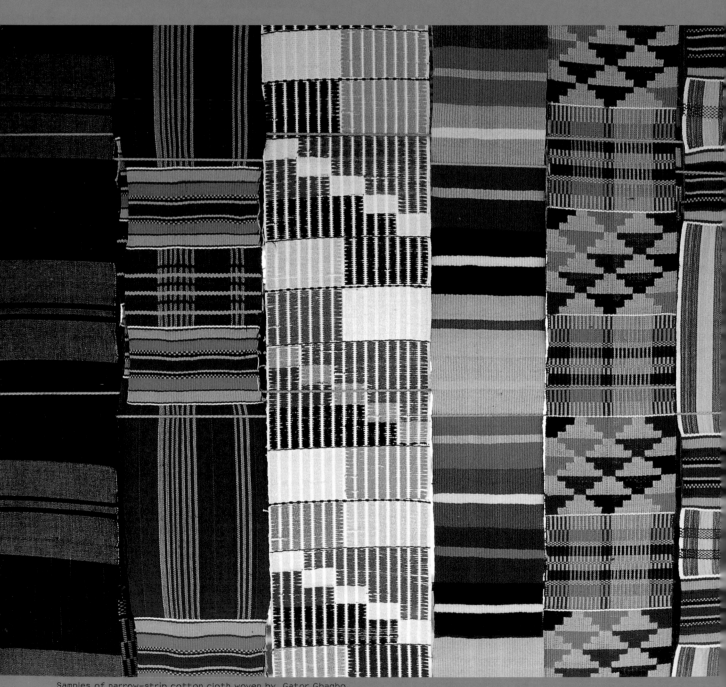

Samples of narrow-strip cotton cloth woven by Gator Gbagbo,
Agotime–Abenyiase, Volta region, Ghana, 1999. They were hanging
beside the road as an advertisment of his skills to passers-by.
Photo by John Picton.

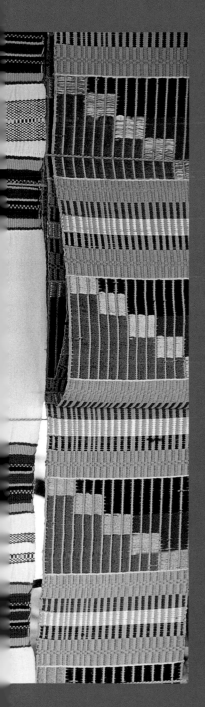

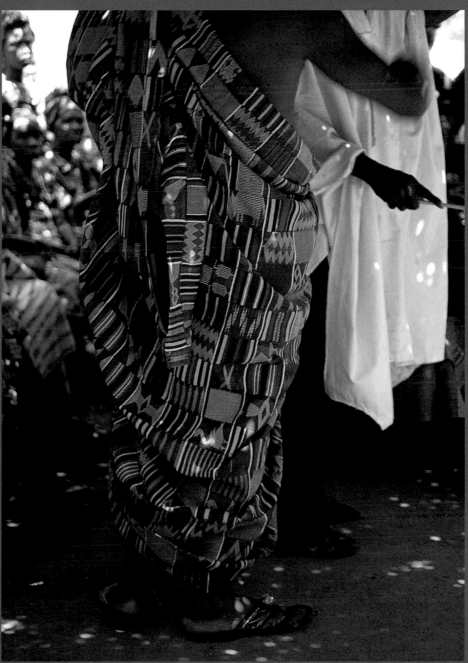

An elder at the coming-of-age rite of some young women,
Afegame, Volta district, Ghana, 1999. Photo by John Picton

BEYOND BINARIES:

RESPECTING THE IMPROVISATION IN AFRICAN-AMERICAN STYLE

SUSAN KAISER, LESLIE RABINE, CAROL HALL AND KARYL KETCHUM

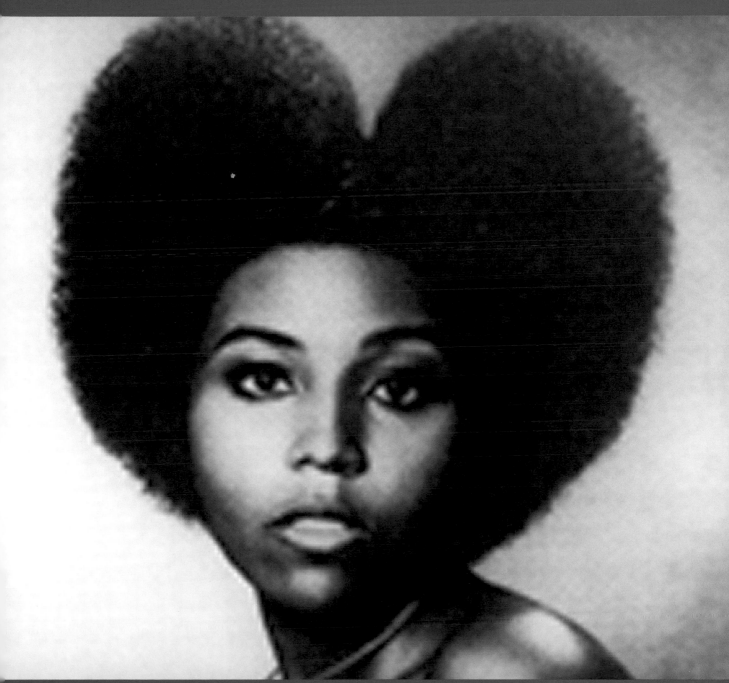

This photograph of a heart-shaped Afro hairstyle was first
published in 1971 and appeared on the cover of *Fashion Theory*
(Volume 1, Issue 4), in December 1997. Kelley (1997) describes
the style, courtesy of Clairol, Inc., as 'Heart and Soul: a sweet,
sweet way to switch your regular style to something special.'

Black people are still trying
to fight for respect. And I
think that has a lot to do
with what you got on ...
People treat you the way
you look ... The only way to
carve out an identity and
the only way to distinguish
ourselves is by what we got
on. Culturally. Psychologically.
Clothes make the man ...
[W]hite male style can be a
lot more varied, because I
think they don't have to
portray themselves in
certain ways to get the
respect of others ... I mean
because right now it's like
pretty much they're running
the country so they can
pretty much dress the way
they want.

Traditionally, as a group of
people, we have been held
back; we just haven't had
anything. So the only way we
can be unique or the only
way we can distinguish
ourselves is on appearance,
because we couldn't really
do anything else, and so that
is why we started dressing
or at least being conscious
of what we had on, and that
evolved into style.

Afro–American culture is a very rich one, and it comes out in how we dress ... dressing nicely, dressing with style, taking things that are found in the dominant culture and changing them ... giving them a flavor of our own.[1]

'Find out what it means to me.' Cynthia Tarver, Director of Women's Studies at Southern University, matches snakeskin-print jeans with a denim jacket, silver-studded mules and a Jaguar Nation cap at the first game of the football season, Fall 1993. © The Advocate.

These beliefs, held by male university students from middle-class African American backgrounds interviewed in the 1990s, point to the importance of style in the everyday quest for respect. The word 'respect' is derived from the Latin respicere, meaning to look back, or take a second look, and its origin highlights how important self-representation is to respect as we understand it today – a sense of regard, or the bestowal of esteem. Implicit in the notion of respect is an awareness not only of oneself as an object of regard, but also, by extension, of one's potential to affect the surrounding world through self-image.

The concept of respect has thus played a crucial part in the empowerment of African American communities. Beginning their American experience as slaves, denied by the U.S. Constitution the status of citizen, disallowed basic rights even after the U.S. Civil War, consigned to the lowest rung of the social hierarchy through rigid segregation, and economically oppressed in contemporary U.S. society, African Americans have always struggled for respect. If, as the legendary African American writer W.E.B. DuBois says, African Americans are caught in 'a world that looks on in amused contempt and pity'[2], they have used the one resource available, their own bodies, to represent the demand for respect. Having struggled with the opposition identified by DuBois over one hundred years ago, the concept of 'double consciousness', of being both American and black: 'this sense of always looking at one's self through the eyes of others'[3], African Americans have found that dress and fashion are a means of attempting to reconcile these two ways of regarding the self. The everyday struggles to achieve this reconciliation command a 'second look', a re-looking that bestows the much-warranted respect from 'the eyes of others'. Aretha Franklin forcefully summarizes this potent, reflexive notion of respect in one of her most famous songs:

R–E–S–P–E–C–T.

Find out what it means to me...

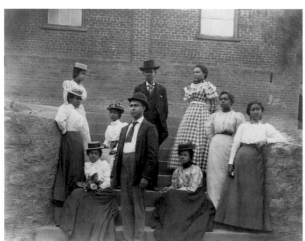

Georgia c. 1899–1900. This photograph was part of an album compiled by W.E.B. DuBois (v. 4, no. 348).

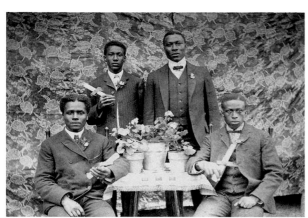

An instructor and three graduates from Tuskegee Institute, c. 1905. The American Museum of Photography.

Respect cultivated through image – styling of the self – can therefore be seen as a way of being and becoming. [4] Style – materialized in a dapper fedora with a large brim perfectly snapped over the eyes; a hip-hop outfit of silver-studded miniskirt, crop-top and track jacket, all in dazzling white; or a sharply cut women's suit accessorized with hat and scarf in West African *kente* or print fabric – has been the visual manifestation of a consciousness that breaks away from the traditional perspectives of the dominant social order. In African-American culture, clothes can become a source of aesthetic freedom. [5]

African Americans have not imitated European American style. Instead, they have drawn upon a rich history of aesthetic creativity and innovation from various West African cultures. Forced to adopt Euro-American dress, they have, throughout their history, articulated their own diasporic form of improvisation that appropriates European American style to create an aesthetic of resistance. This practice has manifested itself in numerous ways, but by borrowing from white, European dress to create a more expressive model of fashionability, the idea of style as resistance – both spiritual and political, but no less beautiful – has permeated African-American self-representation.

African-American style, of course, appears in a multitude of guises determined by a range of different factors, such as social class, age, gender, sexuality and region. To complicate matters further, race and ethnicity are undoubtedly slippery constructs. Many

people in the United States are 'multi-racial' and 'multi-ethnic'. But the political institutions of slavery and Jim Crow[6] segregation resulted in the 'one-drop' rule – specifying that an individual born with just one 'drop' of black blood is technically black in terms of racial classification. Such a history goes a long way in explaining why fashion, as a means of commanding the attention of others, and by extension winning their respect, articulates resistance, while it also constructs aesthetic and cultural traditions unique to African diasporic culture in the US.

Historically, African-American styles have challenged and complicated the dichotomies supported by the European American establishment. We have seen, for example, how African Americans have undermined white-versus-black constructions by appropriating white fashion to create a more striking version of their own; but they have also integrated worlds traditionally kept apart, such as mind (or soul) and body, through fashionable dress that both expresses and embodies emotion; and politics and aesthetics, by weaving these inextricably together.

Over the last few years, the backward baseball cap of the late gangsta rap artist Tupac Shakur, for example, has come to symbolize the creative reappropriation of white style. It is not just what one wears, but how one wears it that is relevant here. As one African-American male university student put it, in 1998:

The emotional input is what makes us different. I can't stress that enough … I'm gonna put my spirit into my clothes … [I]t just comes from the heart and soul, and putting it down, representing … This black hat, the only reason I bought this is to wear it backward … I saw this on TV on "Above the Rim" [a movie] and it's just the way he [Tupac Shakur] had it, it was like it just touched me. I was like, that's something I can see myself doing and feeling confident about, and just, I don't know … you just get that whole hype, that whole feeling, that run of emotions through your bloodstream that you get when I saw it on TV — that's what I felt like.

Bell hooks argues that even – or especially – in the most difficult circumstances, it is of the utmost importance that one should learn to appreciate 'beauty' in style: 'to uplift, to offer a vision of hope, to transform'. This ability has been 'an act of resistance in a culture of domination'.[7] Both the ultra-voluminous men's jeans and the ultra-tight women's dress of twenty-first-century hip-hop style communicate this message of resistance and sense of beauty outside the mainstream. Similarly, Gwendolyn O'Neal argues that African Americans have come to perceive beauty in ways that conflict with European perspectives. Acknowledging that beauty judged according to criteria based on the Euro-American prototype 'can never be attained by African Americans', she continues: 'although enslaved Africans were not allowed to retain their own cultural artifacts, the conditions of slavery did not eradicate their aesthetic

memory'.[8] O'Neal traces this memory back to the aesthetic and cultural histories of West Africa and the Congo. Significantly, it was the practices of these cultures that provided an alternative to the ways in which the European colonialists perceived African appearance. European traders' accounts of West Africa written in the fifteen century focused on two aspects in particular: skin colour, and the clothes worn by African chiefs and kings.[9] Active for centuries as traders in the trans-Saharan trade routes, West Africans of different ethnicities developed a genius for integrating foreign textiles, garments and modes of dress into their own cultures.[10] African men with the means to do so continued this practice when the European traders presented them with fabrics and items of clothing.[11] However, these traders failed to recognize the resulting styles as new creations incorporated within well-formed aesthetic traditions other than their own. Rather, they saw them through a colonial gaze – as 'unsuccessful attempts by an inferior group to imitate white ways'.[12]

Slave traders often deprived West Africans of their clothes on the journey to the 'New World', and upon arrival slaves were commonly separated from those who spoke the same language or belonged to the same ethnic group. They thus formed an overarching African-American culture that managed to find ways of filtering new expressions of style and fashion through older, West African–inspired ideas.[13] Slaves improvised with the only clothes they had available to them, making innovative adaptations that might today be described as 'syncopated' or 'jazzy' but

which were then merely regarded by the Europeans as 'odd'.[14] However, White and White argue that, on the contrary, the African-American ability to combine colours and articles of clothing in a variety of original ways revealed the 'polyrhythmic nature of their culture, a characteristic that also infused other expressive forms, ranging from quilting, dance, and music to speech, and that was illustrative of a particular way of seeing and ordering the world'. Clothing was 'fashioned out of adversity' and yet 'made the lives of African Americans during the time of their enslavement bearable'.[15]

In a similar vein, bell hooks links style directly with a politics of representation:

> The ways we image ourselves, our representation of the self as black folks, have been so important because of oppression, domination. Clothing for us has had so much to do with the nature of underclass exploited reality. For we have pleasure (and the way this pleasure is constituted has been a mediating force between the painful reality, our internalized self-hate, and even our resistance) in clothing. Clothes have functioned politically in black experience … to express resistance and/or conformity.[16]

Indeed, clothing was central to enslaved people's consciousness. As slave narratives suggest, it provided a meaningful medium for articulating the material realities of everyday life, as well as for creatively building complex connections between West African and European aesthetics. Although slaves did not legally own their

own bodies, they found innovative ways to distinguish themselves. Foster argues that clothing became intrinsic not just to a sense of self but also to community, in the face of oppression and domination. Caroline Wright, born around 1845 and about 90 years old at the time of her interview in the mid-1930s, described the final years of slavery as follows: 'Us sho' did come out looking choicesome.' 'Choicesome' – a word fashioned within the context of slavery – implies that clothes and grooming were chosen with care, with a sense of purpose, and with excellent results.[17]

The white colonial gaze continued to influence perceptions of African–American style, however. During and after slavery, when white people observed well-dressed blacks in public settings, especially in parades (most notably, in New Orleans), they could only interpret African–American style as mirroring back to them a comical imitation of European American modes of dress. White people experienced a 'sense of disquiet, a fretful complaint at the blurring of what had seemed relatively clear-cut racial boundaries'.[18] African Americans managed to sustain aesthetic cultural processes of innovation, improvisation and creativity, and to foster a sense of community pride based in part on principles of resistance, within and beyond a sartorial system dominated by white people.

A study of African–American women's dress in Georgia between 1890 and 1914 found that there were many community-oriented sources of information about fashion during this period, including such African American newspapers as *The Atlanta Independent* and *The Savannah Tribune*. By necessity, many women worked outside the home and were thus exposed to fashionable society. Although economic considerations were still critical, and racist Jim Crow laws enforced, African Americans were no longer bound by slavery and now had some degree of choice in what they could wear. African–American authors such as Fannie Barrier Williams wrote about the need for a community to spend clothing dollars wisely.[19]

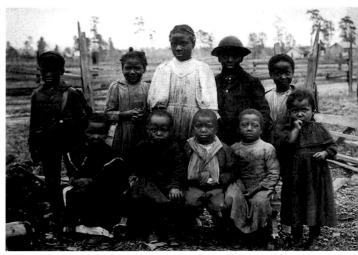

Cyanotype portrait, *c.* 1900. The American Museum of Photography.

In the 1920s and 1930s, during and after the Harlem Renaissance, there were numerous accounts of stylish African Americans in Harlem in their high-heeled shoes and silk stockings, proudly erect in fur-trimmed coats, heads held coquettishly high in cloche hats. In 1931, a *New York Times* reporter described Harlem's 'fashion plates' as 'several jumps ahead of the rest of the world'.[20] In the 1940s, Jelly Roll Morton, known as the father of jazz, proudly described African-American men as 'suit men from suit land'.[21] Already identified as 'different' in US society and often denied access to its world of masculine privilege, African-American men, along with Latino men, used the zoot suit to announce their presence with defiance, marking their differences from dominant, white masculinity, and appropriating the suit as a symbol of power.

Despite the fact that racial segregation continued into the 1960s, community pride and resistance – represented in part by smart dressing and grooming – endured in African-American culture. At the same time, white female beauty standards still imposed a particularly oppressive system that distinguished those African Americans who had 'good hair':

> When a Black child was born, I would hear my mother or other Black women refer to the child's hair as good. They'd say, 'That child has a good grade of hair.' I don't ever recall hearing them say that a child's hair was bad. But between them and the television commercials, the concept of good hair was firmly set in my mind. Good hair was hair that was not curly or coarse in texture. Good hair was not difficult to comb. Good hair had waves if you were male, length and manageability if you were female. I thought something was wrong with us. We weren't rich, we weren't white, and our hair wasn't on television![22]

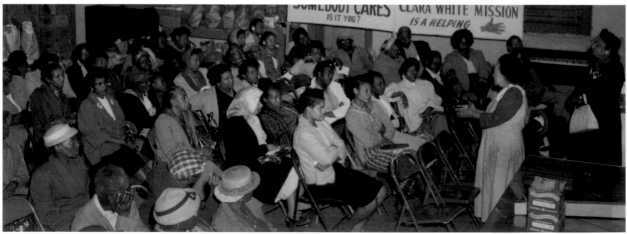

Clara White Mission, c. 1915. Thomas G. Carpenter Library, University of North Florida.

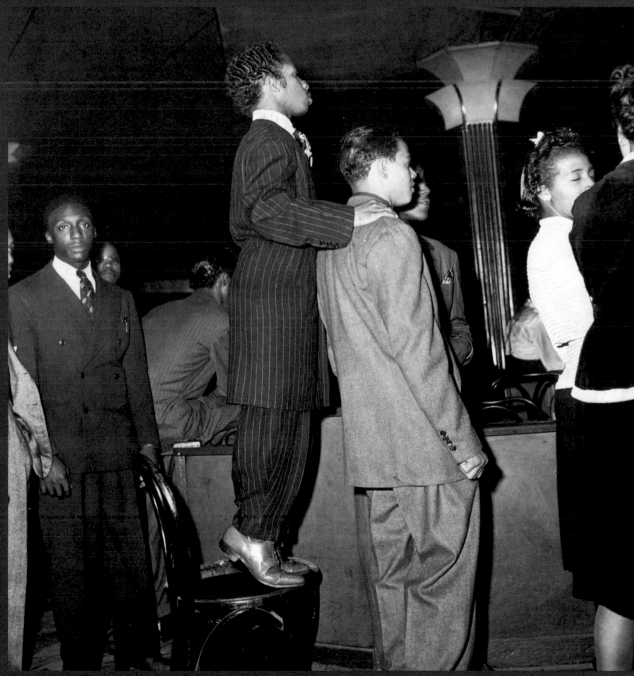

Young men in zoot suits at the Savoy Ballroom, Harlem,
c.1936 © Bettmann/Corbis

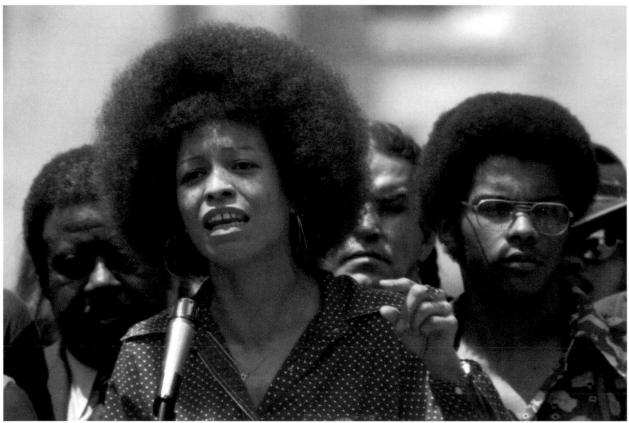

Angela Davis, African-American activist, 1974 © AP Photos

The civil rights movement of the 1960s and 1970s fostered the theme of 'black is beautiful', promoting self-acceptance of black features and grooming that rejected white beauty standards:

> More than *dashikis*, platform shoes, black berets and leather jackets, the Afro has clearly been the most powerful symbol of Black Power style politics. Although hair had long been a site of contestation within black communities and between African Americans and the dominant culture, the Afro, unlike any other style, put the issue of hair squarely on the political agenda. [23]

By the early 1970s, the Afro was losing its connection to black nationalist politics. Kelley argues that the Afro became increasingly masculinized as it was depoliticized, contributing to a backlash against black women with 'natural hair'. [24] Interviews with African-American women in the 1980s and 1990s in both Louisiana and California reveal the extent to which hair remains a central point of concern. In these interviews the women often mention the fact that middle-class mothers preferred longer, straighter hair.

Similarly, an ethos of basic grooming standards pervades interviews with middle-class women and men alike:

My mother grew up in the twenties, thirties, and forties, in the south ... I am sure her mother or folks had the same thing; they put it into my head. Not ruffles, laces, pearls, and all that. Just make sure my hair was combed, and together ... I am always presentable.

Unidentified beauty queens, The San Francisco African
American Historical & Cultural Society Library.

My mother always taught us … to care
just as much about the undergarments
as we do the outer garments … My
mother always told us to wear nice
shoes … If I have a good leather shoe I
still get it shined. I take it to the shoe
shop and get it shined.

I think the main thing my father
enforced is just that when you are
going somewhere you have to dress this
way. You have to wear these slacks and
not jeans. You have to wear this long
sleeve button down shirt and not this
old funky shirt. Your hair has to be
done, correctly. Shoes have to be
polished. You have to be looking
appropriate everywhere you are going.

My father was the role model for all of
us. You will not leave the house without
combing your head. Basic grooming
standards for black folks. You leave
the house looking presentable. You will
leave this house acting like you belong
to somebody. [25]

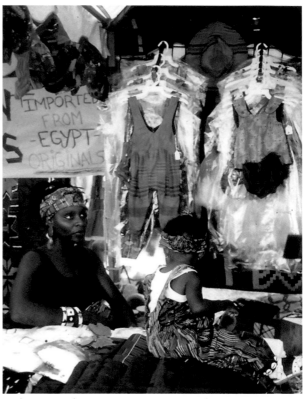

Couple selling jewellery they have designed from imported African beads, c. 1995.

Designer Synovia Jones, The Los Angeles African Marketplace and Cultural Fair, 1993.

The notion of belonging, to the larger community as well as to family, remains a theme of African-American style. In the 1980s and 1990s, the aim of some African-American innovations and creative expressions was specifically to link politics and aesthetics within communities or sub-communities, and many simultaneously re-appropriated dominant white style while also revealing a complex and 'turbulent' relation with it. [26] In explaining this dynamic, Lewis, much like hooks, shows how the blatantly provocative zoot suit of the 1940s and the hair-combed, shoes-shined ethos of respectability and belonging fit together: 'African Diaspora fashion elegantly demonstrates the development of social and psychological issues that the Diaspora comes to terms with by making appearance choices that are distinct but contrary; one type of choice is compliant to the mainstream, the other is a protest against it.' [27]

In the late twentieth century, two styles in particular began to articulate such protest. One is hip-hop, discussed below, the other African-inspired fashion. This latter rejects clothing styles that have

emerged in relation to white supremacy by specifically fashioning a look derived from Africa as ancestral homeland. Although *dashikis* were a symbol of black power in the 1960s, a wide variety of African fabrics and styles was used to create a complex African-American fashion system in the 1980s. African fashions circulated from the African continent into urban black communities in the US through an informal global network of African artisans, transatlantic suitcase vendors and immigrant street peddlers. In fieldwork conducted between 1993 and 2001, Rabine studied the informal African fashion network in Los Angeles. Here African immigrant and US-born fashion, fabric and jewellery designers sell their wares at reggae and jazz festivals, cultural fairs at black churches or parks, and African History Month fairs. The styles range from the voluminous Senegalese and Nigerian *grands boubous*, usually in hand-dyed cotton damask and heavily embroidered, to fitted, high-fashion evening gowns and cocktail suits made out of, trimmed with or accessorized by African fabric. Casual warm-up suits by African-American designer Karimu, and

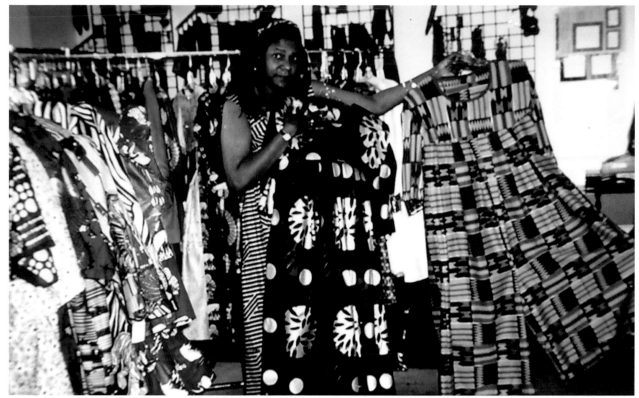

Show room of Senegalese Bassiro Lo's tailor shop in Inglewood, California, 1993.

swing coats by the Senegalese tailor Bass are graced with appliqués of African fabric.

Identity politics of the late twentieth century, as materialized in African-inspired fashions, coincided with the new age of globalization in which consumer capital, with its transnational webs of cheap production, computerized distribution and mass-mediated advertising, deploys its power to sweep cultural movements into euphoric marketing slogans. On the one hand, African fashion remains marginal to corporate consumerism and is sustained to a great extent by an informal economy, either through artisanal production with direct exchange between producers and clients, or through imported goods sold by street peddlers. Yet on the other hand, codes of mass consumption are so powerfully internalized in the US that many, though not all, African-American consumers interpret African-inspired dress through them – interpretations that connote a relatively unified and idealized ancestral homeland. In contrast, for artisanal producers, the fashions do not suggest this generalized Africa, but their own

memories of a particular community on the continent, with its particular fashion system. In many countries of West Africa, fabric is a major art form, while tailoring and dyeing are highly respected crafts. Important to each designer are the connections the styles make to a remembered place, where so-called traditional clothing and fabric have themselves resulted from a centuries-old history of intercultural dissemination. (see chapter 2, 'What to wear in West Africa').

African immigrant designers defy the stereotype of African-influenced fashion as a mass-produced, reductive icon of a generic, timeless 'Africa'. Karimu, who has lived in South Central Los Angeles all her life and has her workshop there, also rejects the stereotype, expressing instead a fervent attachment to the place and its community as matrix for her craft. She weaves together her intense attachments to her neighbourhood and to fashion creativity. But precisely because she resembles the African designers in drawing her creativity from her locality, her designs do not have, as she puts it,

'the traditional Afrocentric look'. They do incorporate African printed woven fabric, but for Karimu, African-American dress follows a US black tradition of 'glamorous fashion' that she remembers her parents wearing – a style that has a 'classic line' and is 'not a fad'. Style models for Karimu are 'Bob Mackey designs for Diana Ross'.

O'Neal's study of Midwestern African American professional women who incorporate Afrocentric styles into their daily wardrobes focuses on those who go beyond the ideological codes of mass consumerism to express a complex cultural awareness. O'Neal notes how this helps to 'balance the tension created by the dual self … a sense of being neither fully American nor fully African'.[28] As DuBois had noted at the beginning of the twentieth century, this experience involves 'two souls, two thoughts, two unreconciled strivings: two warring ideals in one dark body…'.[29] One of O'Neal's informants comments that Afrocentric dress completes:

> … the whole picture of who I am and where I'm from and all of that … and that's inclusive of my American dress as well as my return to African dress … I think it's a part of what represents who I am: a combination of an African woman and a woman who was born in America.

Another reveals that she uses Afrocentric dress to recognize her ancestors:

> At the same time it's not practical that I would go totally into the dress of my ancestors. So I try to pull them

together. And the things I continue to purchase as well as the things that I have had in my wardrobe before, I began to integrate. I am a woman of African descent, born in America. That is who I am …[30]

In 1993, Spiegel Catalog and *Ebony* magazine began to target African-American women in a specialty catalogue called *E-Style*[31], following the lead of giant corporate retailers such as J.C. Penney's. Two years before, sensing a market in clothing that was at that time traded informally, J.C. Penney's had begun to appropriate African-inspired fashions for mass-production and sale to African-American consumers.[32] In 1992, Penney's set up production in a small factory in Senegal, but when this failed, its 'authentic African' clothes were actually made in sweatshops in Pakistan.[33] The cheaply manufactured fashions degraded both the aesthetic qualities and the political meanings of the original African-inspired dress. As a result, the popularity of Afrocentric fashion faded by the end of the 1990s. African Americans motivated by cultural awareness, such as those interviewed by O'Neal above, continue to wear the styles.

In its appearance, its meaning and its relation to mainstream consumption, African-inspired fashion differs from the other main style trend of the late twentieth century: hip-hop. Where devotees of the former tend to be older and more middle-class, hip-hop receives its creative impulse from inner-city youth culture. Where African-inspired fashion confronts white supremacy by expressing

Run-DMC, 1986 © Ebet Roberts/Redferns Music Picture Library

a proud dignity, hip-hop subverts establishment notions of racial difference through cutting-edge styles that throw back in the face of mainstream America its own stereotypes of inner-city black youth. Yet ironically, given the audacious expressions of rebellion in hip-hop, it is African-inspired fashion, even when mass-produced, that has remained within the black community and has kept a stable meaning of black resistance. Hip-hop styles, on the other hand, are continually appropriated by mainstream culture and corporate mass production. No sooner, for instance, does an innovator turn his baseball cap backwards than white middle-class youth adopts the look, and manufacturers produce baseball caps made to be worn backwards with an extra logo stitched across the back.

In its very instability, then, hip-hop dress, as it vibrates between protest and mainstream commodity, expresses the status of African Americans at the beginning of the twenty-first century. US economics increasingly marginalize and impoverish African Americans while at the same time black culture, especially in the form of hip-hop, moves out of its historical exclusion from the mainstream to gain widespread acceptance in the dominant media. Hip-hop fashion thus visually represents not just resistance, but

the more complex concerns of socially conscious African Americans as well. It represents a new version of 'double consciousness' which Cornel West calls a 'double bind'.[34] Many black intellectuals see this double bind as both potentially dangerous to the politics of resistance and potentially beneficial; Boyd perceives it as 'the space between the points where radical political discourse can critique dominant culture and dominant culture becomes financially viable through the selling of this oppositional discourse'.[35] It is this ambiguous space, with its potential for resistance to and recuperation by mass-mediated culture, that current African-American fashion, in the manifestation of hip-hop, styles and embodies.

Yet as quickly as the media and fashion industries commercialize a hip-hop look, just as quickly do young African Americans on the street invent new ways to subvert mainstream clothing, wearing items in ways that their manufacturers could never have imagined. These have included track suits worn as day wear; baggy track suit trousers mixed with preppy Tommy Hilfiger shirts; athletic shoes worn with laces untied; hooded sweatshirts worn with the hood up even indoors; and white T-shirts worn with one arm stuffed inside the shirt.

In 2003, in the African-American community of San Francisco, one young man wears ultra-baggy sweats, heavy jewellery, and a do-rag all in sombre black. His male companion repeats the outfit in striking white. Since mass-produced do-rags only come in black, the man winds a white T-shirt around his head. Like earlier styles, this cultural use of black and white clothing to break out of the black-white racial binary speaks to an attitude that O'Neal's informants articulate for different genders, ages and class groups:

It's not only just putting the object on, but bringing that style to it … You have to have passion to dress the way we do.

We've always had our own … style. We may wear the same name brands … as … everybody else, but we style them differently.

It's something about the way a Black woman puts a hat on her head … It's not so much what you do, but it's the attitude and the spirit with which you do it.[36]

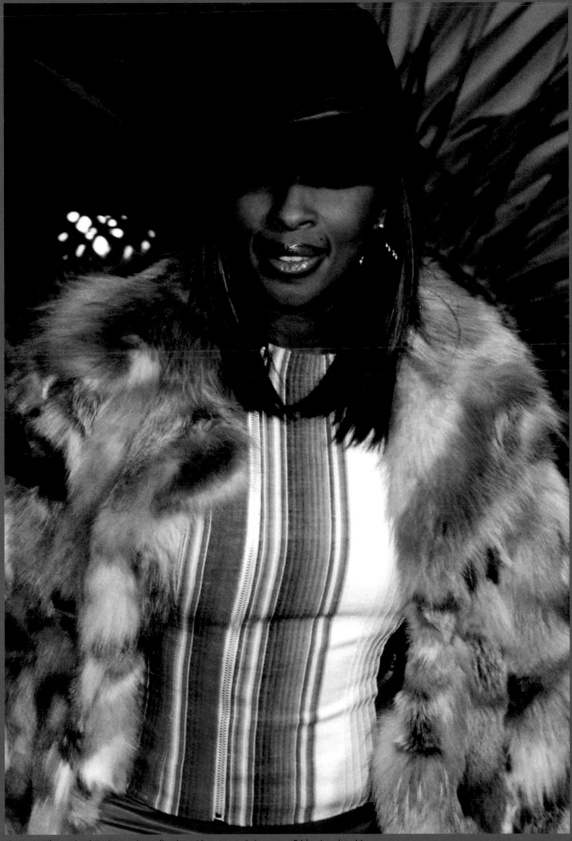

Mary J. Blige, who has been described as the current 'queen of hip-hop/soul.'
2001 © Christina Radish/Redferns Music Picture Library

DANCEHALL DRESS:

COMPETING CODES OF DECENCY IN JAMAICA

CAROLYN COOPER

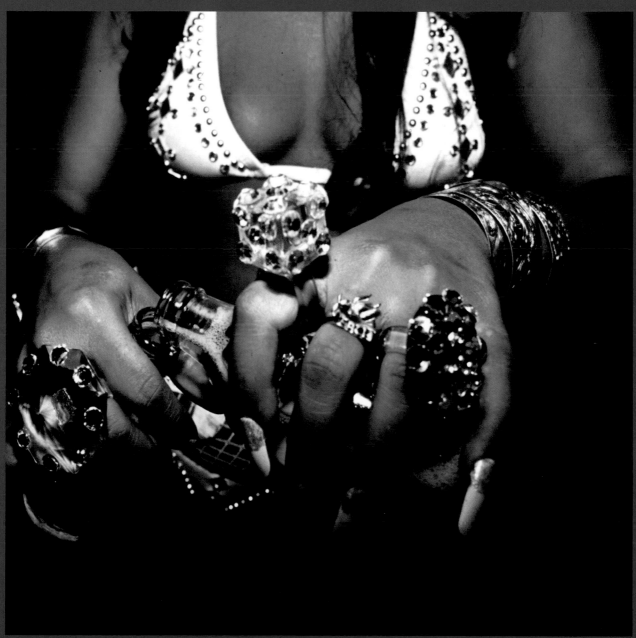

UrbanImage.tv/Wayne Tippetts

The fantastic (un)dress code of the dancehall in Jamaica is a glamorous expression of a distinctive cultural style that allows women the liberty to demonstrate the seductive appeal of the imaginary – and their own bodies. Their spectacular appearance – the hair, make-up, clothes and body language — enhances the illusion of a fairy-tale metamorphosis of the mundane self into eroticized sex object. In an elaborate public strip-tease, transparent bedroom garments become theatrical streetwear, somewhat like the emperor's new clothes. And who dares say that the body is naked? Only the naïve.

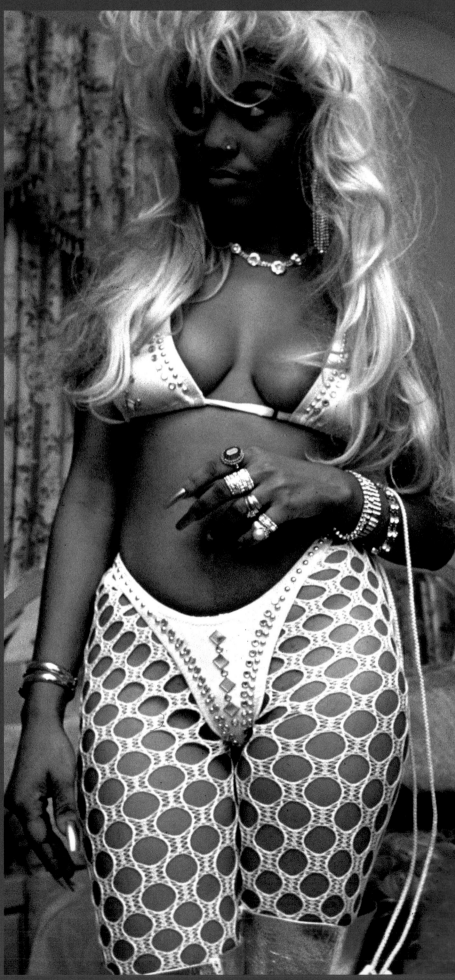

UrbanImage.tv/Wayne Tippetts

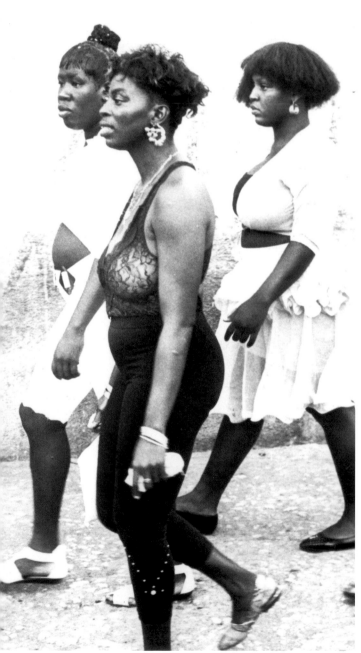

Photo: Winston Sill. © The Gleaner Company Ltd

A decade ago there was a wicked notice posted at the entrance to the Emergency Department of the Bustamante Children's Hospital in Kingston, Jamaica. I use the word 'wicked' somewhat ironically, in both the Jamaican and the traditional English sense of the word. 'Wikid', in the Jamaican vernacular, is a subversive term of high praise, like the African American 'bad'. It means, among other things, 'outstanding', 'top of the line', 'really great', the very opposite of the English definition of 'wicked' – 'vicious', 'cruel', etc. The Emergency Department notice was headed 'Dress Code', and was addressed to 'Mothers & Guardians'. This is what the sign said:

I. Please cover all body parts!!
II. Please attend to personal hygiene!!
III. No setters in hair!
IV. NO Dancehall Style!

Next to item III, someone had inserted 'yeah man'. At the very bottom of the notice someone else had written 'Perfect'.

As I sat there copying the notice, I overheard a conversation between two women who had observed my rather active interest in the sign. Well, it was not quite a conversation. The women did not address each other (or me) directly. The exchange had a stylized, combative, 'throw word' quality. The first woman simply tossed out the following comment to the evening air:

'Lang taim dem fi put op a sain laik dat. Ef yu eva si di wie di uman dem dres fi kom si dakta. Di huol a dem paats a shuo. Kot out dis an kot out dat. Dem fi du somting bout i. Dem fi av rispek fi di dakta dem.' ('They should have put up a notice like that a long time ago. If you ever see the way the women dress to come to visit the doctor. All of their body parts are exposed. Clothes with bits and pieces cut out. They must do something about it. They must have respect for the doctors.' Words to that effect.)

It had not occurred to me that my act of copying the notice might itself generate a critique of the power relations that underlie the dress code. So I was not prepared to record the women's responses to the notice. Had I thought of it I could have planned to do a survey, however modest, of the perceptions of 'Mothers & Guardians'. I would have been equipped with my tape recorder. Unfortunately, like many an adventurer, I had left home without that essential 'it'. So I cannot report, word for word, what the women said. Paraphrase is inevitable, but I have not editorialized.

The second woman, whose sentiments I must confess I share, was outraged by the censorial intention of the sign: 'Ef mii de a mi yaad an fi mi pikni yai a ton uova, mii fi tap fi go dres op fi kom a aaspital? Dem mosi mad! A wa dem tek dis ting fa? Eniting mii av aan, a dat mi a wier kom a aaspital. Aafta raal. Dem out a aada.' ('If I'm at home and my child's eyes start to turn over, I must stop to dress up myself to come to the hospital? They must be crazy!

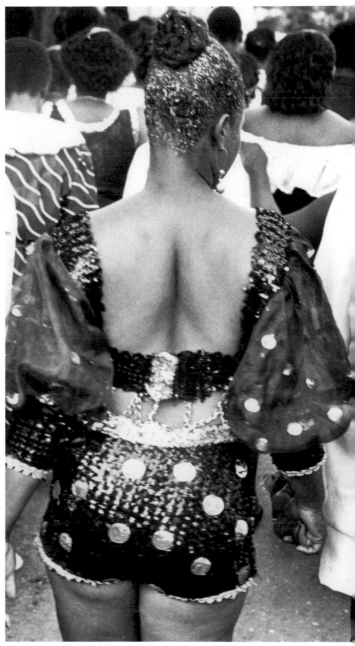

Photo: Winston Sill. © The Gleaner Company Ltd

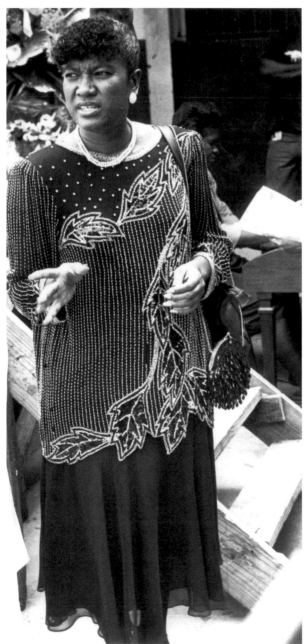

Photo: Winston Sill. © The Gleaner Company Ltd

Don't they understand what an emergency is? Anything I have on, that's exactly what I'm going to be wearing to the hospital. After all! They're out of order.')

The very idea of enforcing a 'dress code' at the emergency department of a hospital is a violation of common-sense codes of decency: hospital haute couture as 'sick style'. I concede that a 'dress code' might make sense at a clinic, where visits are prearranged and clients going to keep appointments with Destiny do have the opportunity to select their garments carefully and ensure that all their body parts are covered. They can attend to matters of personal hygiene. And they can take all the 'setters' (curlers) out of their hair.

There was another wicked 'Dress Code' sign at the Comprehensive Clinic in Kingston, which I've not seen for myself. I take the word of the poet, Lorna Goodison, who reports that the sign said 'Please bathe and smell clean for the doctor. No shorty shorts, no rollers, no lingerine.' Yes, 'lingerine' – a lovely malapropism suspended somewhere between 'lingering' and 'lingerie'. I do understand the class politics of the guardians of respectability at both hospital and clinic who are trying to keep out the riff-raff and enforce 'dress codes'. Nursing and doctoring in public institutions in Jamaica is such a frustrating business that many practitioners feel they must insist that their clients give them maximum respect.

In 2003 another much more prominent sign appeared at the very entrance to the Emergency Department, with the same censorial intention, headed 'Parents Dress Code':

No rollers in hair
No elaborate jewels
No bareness of body
No dancehall fashion

In November that year I telephoned the Hospital's CEO to find out how exactly the dress code is applied to potential clients. Although I was relieved to discover that in genuine emergencies the code is disregarded, for non-emergency visits it is firmly enforced: the security guard at the hospital gates refuses entry to inappropriately clad visitors. The hospital administration does, however, make provisions for such visitors and offers the option of a coat (such as that worn by a doctor) or a T-shirt to cover the offending body parts. An interesting argument is offered by the CEO to support the directive: the clothing is 'protective' – it is a matter of infection control. In a tropical climate, bare backs, bellies and legs generate sweat which can transmit harmful bacteria. The question of the indecency of dancehall dress becomes secondary in this explanation, but the argument certainly cannot be marshalled to justify the prohibition of 'elaborate jewels' and 'rollers'. There is a problematic conflation of aesthetic, moral and public health issues.

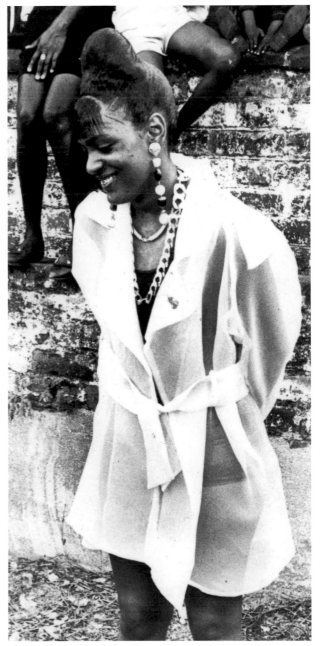

Photo: Winston Sill. © The Gleaner Company Ltd

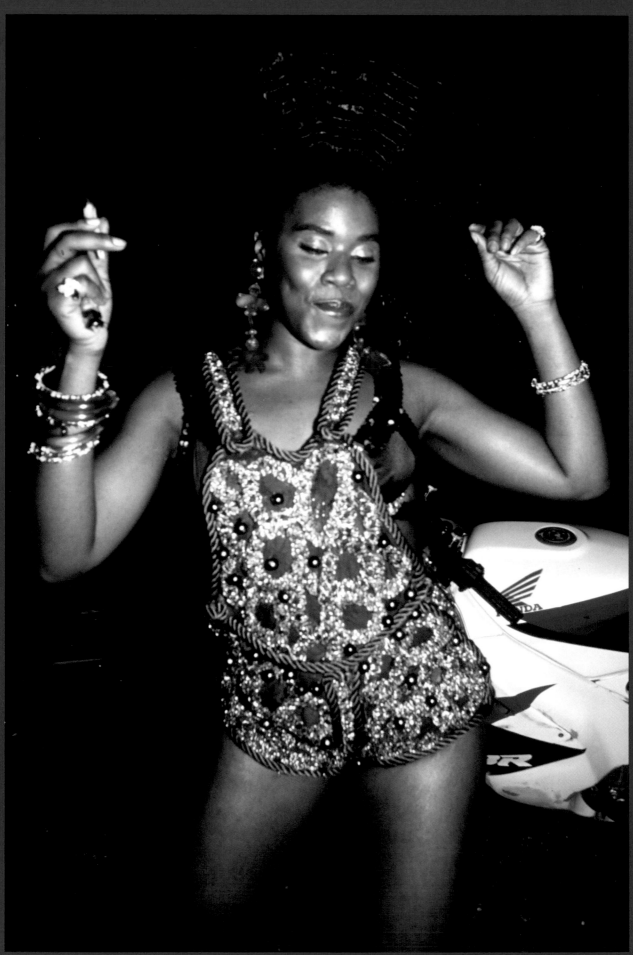

Indeed, it clearly has not occurred to these guardians of sartorial decency, themselves dressed in uniforms of authority, that 'dancehall style' may be some women's dressed-up, good clothes that signify respect for the seriousness of an occasion. The social problem that these official and officious public codes of conduct underscore is the question of competing standards of decency and respect in Jamaican society. Rigid elitist beliefs regarding the appropriateness of certain dress styles for particular occasions are regularly contested by fluid, popular definitions of all-purpose high style. Thus, for example, establishment ideas about appropriate mourning dress for funerals contrast vividly with the practice of working-class women whose dress sense confirms their belief in 'dancehall style' as the badge of good taste.

A classic example of this clash of styles was evident in the 1992 hullabaloo in the local press about the dancehall 'evening wear' that mourners donned to pay their last respects to a fallen community leader at a morning funeral. There was much mockery among middle-class voyeurs of the 'inappropriate' threads. A full-page spread of photographs appeared in the *Sunday Gleaner* of 15 March 1992. The headline for the story, written by Norma Soas, was 'Mourning as Spectator Sport'. Soas, herself a successful uptown fashion designer, did challenge middle-class presumptions about appropriate funeral dress. But her 'us' and 'them' rhetoric seemed somewhat condescending:

For most of us, a funeral is a mournful occasion, but maybe for those attending this particular funeral it was a celebration of the life of the deceased, hence what is appropriate for the dance hall would be just as appropriate at the funeral … They were dressing for an occasion, and this was one of the biggest in their community. This therefore was not inappropriate dress in their eyes. Rather, these styles are de *rigueur* for any situation for 'profiling', as this undoubtedly was.

Dancehall style is a vivid affirmation of the pleasures of the body, displayed to full advantage. Its codes are often misunderstood as signs of the devaluation of female sexuality. But this sense of style can also be seen as empowering. Woman as sexual being claims the right to sexual pleasure as an essential marker of her identity. Both fleshy women and their more sinewy sisters are equally entitled to display themselves in the public sphere as queens of revelry. Exhibitionism conceals ordinary imperfections. In the dancehall world of make-believe, old roles can be contested and new identities assumed. Indeed, the elaborate styling of both hair and clothes is a permissive expression of the pleasures of disguise. In the words of dancehall diva Sandra Lee: 'The extension add a movie look to us … Is like a disguise. I want to look different tomorrow.'[1]

In the 1997 film *Dancehall Queen*, set in Jamaica, the star, Marcia, is initially an unglamorous street vendor, pushing a heavy cart through the streets of Kingston in the unending struggle to survive. She

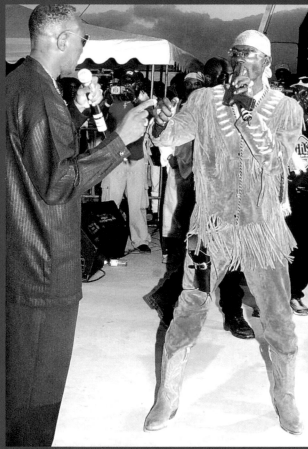

Dancehall style for male performers is often quite theatrical.
Here DJ Ninjaman, dressed in a resplendent cowboy suit, engages
in dialogue on stage at Sting 2002 with Senior Superintendent
Reneto Adams. Photo: Ian Allen. © The Gleaner Company Ltd

recognizes the power of costume to enable transformation when she encounters the reigning Dancehall Queen, Olivene, in street clothes; in the glare of daylight she is struck by the pedestrian quality of the woman. I use 'pedestrian' deliberately because in Jamaica, as elsewhere, cars are often marketed as a fashion accessory that can add immeasurable style to their occupant, somewhat like Cinderella's pumpkin chariot. Marcia is thus inspired to bid for Olivene's crown.

The glittering strobe-light world of the dancehall is an idealized space in which fantastic identities can be created. Once out of costume, the glamorous fairy-tale princess/hard-core dancehall queen often loses her appeal. Stripped of accessories, she is put to the test and found wanting. Indeed, Marcia's incredulous and malicious comment about Olivene, 'she look[s] ordinary eeh!', signals her own recognition of the distance between the nocturnal image and the daylight reality. When Marcia eventually wins the crown of Dancehall Queen, it is essential that she resume her costume as street vendor in order to reclaim her own sense of identity; yet she thoroughly enjoys the fairy-tale fantasy of hypersexuality that the stage properties of the dancehall engender. Indeed, the Dancehall Queen persona permits Marcia to savour the sensuality that had been repressed in the drudgery of her everyday existence; she is able to attract suitors, such as the videographer himself, for whom she becomes the seductive 'Mystery Lady'.

His camera's eye redefines Marcia as a worthy subject of attention, bedecked in all her borrowed glory. She unashamedly revels in the male gaze. No feminist anxieties of 'objectification' disturb her. Indeed, quite early in the game, when he turns his camera away from her to acknowledge the presence of reigning dancehall queen, Olivene, Marcia gets into a huff. She wants to be the singular focus of his attention. Desire – both hers and his – rehumanizes Marcia, putting her at centre-stage. And even after she is stripped of her disguise she remains attractive to him. The role of dancehall queen creates residual benefits which Marcia now transfers to her 'real' life. In the dancehall scene, marginalized working-class black women in Jamaica can assume the habits of seduction to full advantage. For example, in the putting on of wigs, weaves and extensions in various hues, 'picky-picky head' women[2] go to all lengths to claim the sex appeal that is perceived to reside naturally in 'tall-hair' women,[3] as evidenced in the dominant images of pin-up female sexiness in the mainstream media in Jamaica and elsewhere. Hairpieces do for some women what dreadlocks, and the even more fashionable 'sisterlocks',[4] do for others. Although length and volume of store-bought hair are essential elements of style, height is also crucial and adds another layer of constructed beauty that altogether bears absolutely no resemblance to contemporary European-style modes of hairdressing. Dancehall hairstyles are engineered and require sophisticated technical skills for their construction.

Indeed, this dancehall hair-extension aesthetic must be acknowledged as a contemporary expression of traditional patterns of hair and body adornment in continental Africa, which have now gloriously re-emerged in the diaspora. As they flash

their Rapunzel tresses, these dancehall divas engage in a sophisticated game of roleplay. They seemingly buy into the racial ideology that devalues the 'natural' beauty of African-Jamaican women and undermines their self-esteem: 'making up' the body as compensation for its perceived deficiencies. But at the same time, they buy out of the stereotype of the 'ugly' black woman by appropriating glamour within a distinctively black aesthetic. 'Making up' becomes an expression of the pleasure of artifice.

In her entertaining and instructive ethnographic study, *Hair Matters: Beauty, Power, and Black Consciousness*, Ingrid Banks confronts the subject of the politics of hair head-on. In the chapter 'Splitting Hairs: Power, Choice and Femininity', she documents the voices of women who assert their right to self-definition, and identifies the often contradictory politics of liberation that is manifested in the hairstyling choices of African-American women, and, by extension, their Caribbean sisters:

> An important critique of the self-hatred account of hair alteration is that it does not take into consideration hairstyling practices that reflect how black women exercise power and choice… . The possibility that hairstyling practices, in whatever form, serve as a challenge to mainstream notions of beauty or that they allow black women to embrace a positive identity is important for two reasons: voice and empowerment. Voice is important for marginalized groups in U.S. society, and it is through voice that black women are not merely victims of oppression. Instead, black women are agents or thinking and acting beings who understand the forces that shape their lives. [5]

A similarly sophisticated reading of the make-up practices of black women must take into account the many shades of meaning that the brush paints. In some instances, make-up functions explicitly to mask or erase distinctly 'African' features. Techniques for reducing the width of the nose, for example, require a subtle play of light and shade to highlight the bridge of the nose and downplay the surrounding flesh. Nevertheless, there is an element of pure artistry and empowering aesthetic pleasure in the practice of making up that should not be denigrated.

The title of Banks' book, *Hair Matters*, clearly echoes Cornel West's *Race Matters*. By thus equating 'race' and 'hair' she elevates a 'woman's' issue to the centre of the argument. If race matters, hair matters as much because hair marks socially constructed racial difference. As Banks observes, 'hair shapes black women's ideas about race, gender, class, sexuality, images of beauty, and power'. [6]

In the patriarchal politics of most societies women are required to be beautiful, unlike men who are allowed to be their natural selves, however ugly. In the derisory words of the self-important male character, Ubana, in the novel *The Joys of Motherhood*, written by the Nigerian Buchi Emecheta: '[a] woman may be ugly and grow old, but a man is never ugly and never old. He matures with age and is dignified.' [7] For

many African diasporan women, the politics of beauty is complicated by racism. Unlike their African sisters, for whom beauty was traditionally defined in indigenous terms, many African women in the diaspora are judged according to alien criteria, and thus have had to settle for being 'sexy' instead of beautiful.

There is an old Guyanese joke about an African-Guyanese woman who entered in a beauty contest in the mid-1960s. The story was told to an African-Guyanese woman who worked at Fogarty's, a Georgetown store that tended to have a disproportionately high percentage of Portuguese and other light-skinned employees. The woman, unsuccessful in the competition, is alleged to have responded thus to a malicious question about how she had fared:

For figure and face
I ain't mek no place
But for bubby an arse
Ah bus deh rass.[8]

Not all African diasporan women share the confidence of this contestant. In fact, the beauty contest culture in Jamaica, for example, still privileges the mulatto 'browning', and occasionally the 'white' woman, as the ideal representative of this 'out of many, one people' nation in international beauty competitions.

Furthermore, there is a disturbing trend in the Caribbean today for black women to bleach their skin in an attempt to approximate the beauty ideals of Euro-Americans, especially the mulatto variant. This bleaching of the skin – usually only the face and neck – is an obvious attempt partially to disguise the racial identity of the subject. The mask of 'lightness', however dangerous in medical terms, assures its bearer status in a racist society that still privileges melanin deficiency as a mark of beauty.

Another alarming new development is the ingestion by some women of the 'chicken pill' – the hormones used in the factory farming of poultry to accelerate the fattening of the livestock. The slang term 'chick', meaning a young woman, becomes all too literal in this context. Bypassing the normal, 'nutritional' procedure of eating the chicken itself, some women experiment on themselves, hoping to construct the body type that is so highly valued in working-class culture: large breasts and bottoms. This full-bodied image is a radical rejection of the anorexic body type of the ideal beauty contestant. Somewhat contradictorily, these bleaching and fattening transformations encode models of beauty from contrasting value systems.

This passion for experimenting and playing the other underscores a hidden parallel between the annual rituals of carnival masquerading in other Caribbean societies and everyday Jamaican dancehall culture. The importation of an adulterated Trinidad carnival aesthetic into Jamaican popular culture has resulted in the cross-fertilization of traditions of roleplay in which costume, dance and music are central. Carnival creates a platform for predominantly upper/middle-class brown and

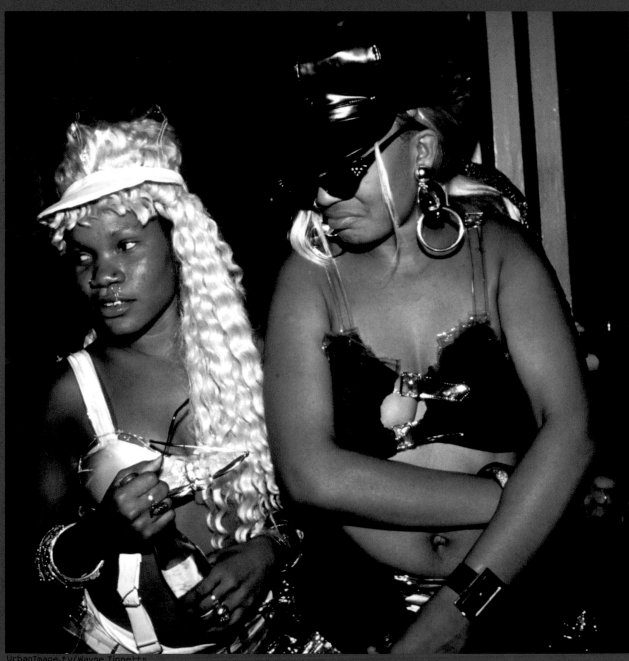

UrbanImage.tv/Wayne Tippetts

white Jamaicans seemingly to abandon
respectability, parade their nakedness in
the streets and 'get on bad' (pass for
black) on their terms. Everyday Jamaican
dancehall culture permits the black
majority to enjoy the pleasures of
release from the prison of identity that
limits the definition of the person to
one's social class and colour. There are, it
is all too true, profound psycho-
sociological underpinnings of this desire
to be, or play at being, the other that
cannot be simply written off as mere
entertainment. Roleplay both conceals
and reveals deep-seated anxieties about
the body that has been incised with the
scarifications of history.

So we come full circle. Since the life-and-
death condition of so many of the public
hospitals and clinics in Jamaica is such a
stark reminder of our mortality, perhaps
we need to celebrate the body while it
still functions. I propose a revised dress
code for 'Mothers & Guardians' at the
Bustamante Children's Hospital (and for any
Fathers in attendance):

I. Please uncover all body parts!!
II. Please smell natural!!
III. Please put setters in hair
IV. Please, please, please
 strictly Dancehall Style!!!
 Yeah man! Perfect!

CHECK IT:

BLACK STYLE
IN BRITAIN

CAROL TULLOCH

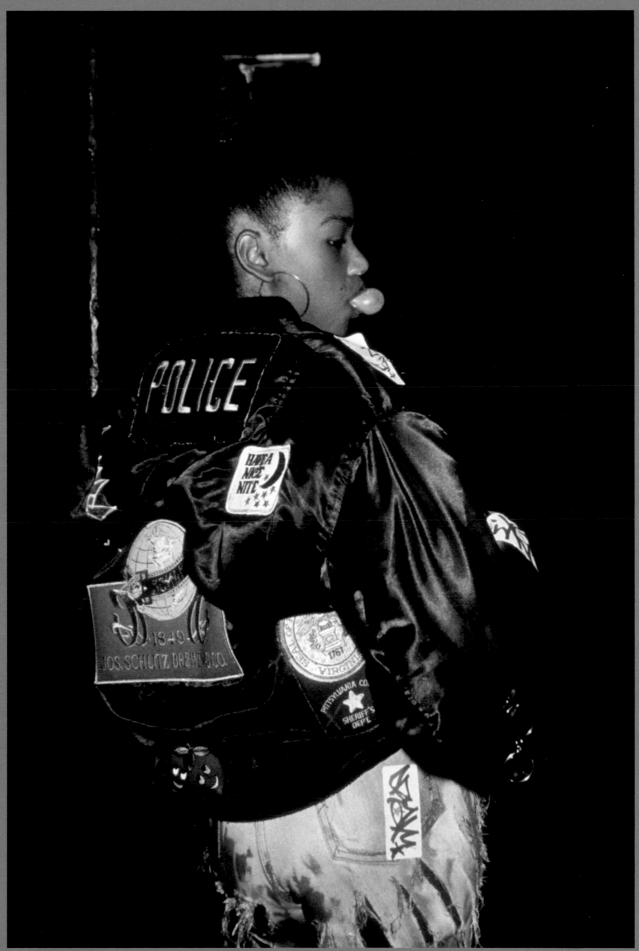

The Astoria, London, 1987 © Derek Ridgers/PYMCA

'Check dem de style,
Check dem de fashion,
Elementary'
Horace Andy

West Bromwich, 1970s © Vanley Burke/Birmingham Central Lirary

This seemingly straightforward directive from Jamaican reggae artist Horace Andy in fact instigates a close and involved study of style and fashion as a fundamental act of cultural interaction. 'Check' has a variety of meanings, each evolving in a different social world. Within street culture, it emerged in the United States during the 1920s as a general term of affirmation, developing into an invitation to inspect, as well as to criticize. Between the 1960s and the 1990s 'check this' or 'check it out' was understood as a request to pay close attention to something, while also acquiring the meaning in African–American slang 'to keep in line, pay attention' (OED). From the 1980s the term was used by black Britons and West Indians in connection with social relations. 'Check' can also be about competition and confrontation. It has its origins in the game of chess as a declaration of an attack that threatens the king. Parallel to Andy's bidding, 'check' has also come to mean a detailed examination to ascertain the 'truth'; 'to investigate, examine for accuracy, authenticity or a confirmation of fitness' (OED).

The relevance of these variations and nuances of meaning becomes apparent when one comes to consider black dress in Britain. Black people are not the only social group to turn heads on the streets, but it is their attention to detail in the art of dressing that has highlighted style performance across the country. They have used clothes, shoes, accessories and hairstyles – the whole gamut of dress – to create different styles and fashions for different purposes. Not least is a visual assault on

racist ideology, most famously imbued in the Afro hairstyle, and less obviously in the tracksuit, popularized as part of the adoption of hip-hop culture by black youth from the 1970s onwards. Dressing up can also be a projection of styling skills and sartorial competition, while it has an alternative guise as chaste flamboyancy in accordance with religious beliefs. Therefore to request that one 'check' the different styles of dress embraced by black people in Britain, as featured in the pages that follow, is to draw attention to the fact that the process of selection and emphasis on dress is compounded, whether consciously or not, by such extenuating issues as difference, pleasure and performance.

The photographs reproduced here depict black people from different age groups, mainly from England's first and second cities, London and Birmingham. They are not 'exotic' examples of another way of being across Britain; rather they illustrate the different ways black men, women and children have styled themselves. The pictures, which span the years from the 1950s to the present time, have been organized thematically to highlight the variety of lifestyles that co-exist within black culture and thus to dispel the persistent idea of homogeneity within it. Hats are a useful example, since they feature in many different categories. The knitted 'tam' worn mainly by black youths in the 1970s was part of their commitment to a celebration of 'blackness', and for many, Rastafarianism. At the same time fashionable hats worn by older women to complement their attire at religious gatherings provide them with the elegant sobriety needed for the occasion. The ubiquitous baseball cap donned by the artist Goldie, along with his arsenal of jewellery, espouses the 'bling' culture of a man who is resolutely urban. Millinery has been an essential component in the construction of street or non-secular cultures, defining a particular group or individual identity at a time when hats are no longer a requirement of sartorial etiquette.

Madeleine Ginsburg has stated that the cultural meaning of the hat can be a mark of dignity that 'is bound up with different concepts of respect to a supreme being ... as well as to family and society'.[1] This applies equally to the continued use of hats by black people since the arrival of migrants in Britain in the late 1940s. As a feature of the black dress aesthetic that has developed here, millinery has become a fervent chronicler of black culture. This is manifested not only by what is worn but also by how it is worn: a back-to-front baseball cap, or a hat positioned to indicate revelry in secularization. Black people have seized on millinery's ability to transform the expression and personality of the wearer, and to signify 'What I am like — or this is what I would like to be'.[2] Of course, hats are only one example; there are many others, such as trainers or the suede trim of a 'yardie' cardigan. Black people in Britain possess an inherent attention to detail which is a nuanced response to such complex social issues as cultural difference and racism, alongside cultural idioms that include appearance and performance through the detailed styling of the black body.

The black dress aesthetic has made use of contemporary and historical references from different parts of the African diaspora, and has also been influenced by other factors and pressures: Western culture; urban prowess; affinity with a particular group identity; innate pleasure in one's femininity, masculinity or sexuality; and the unrestrained desire for the ingenuity of designer clothes. It also has the ability to help soothe personal trauma. In 1994 Zarrah Ahmed-Kadi sought refuge for herself and her four children in Bromley following a military coup in her homeland, Sierra Leone. Her African wardrobe maintains a vital connection with a part of her life that has vanished. In 2003 Zarrah donated an African outfit she brought with her to England to Bromley Museum.[3] It consists of a wrapper (skirt), matching blouse and headwrap, all made of what she calls 'European cotton'. Although she has now lived in Britain for ten years, the ensemble still serves as a vivid reminder of the violent urgency of her flight:

> It was one of the things that I just got into a suitcase, you know, without thinking … It's traditional, you know, just simple without the embroidery you see people wear everyday, but with the embroidery, it's for more festive occasions … it reminds you of your lifestyle back home. Because these are the only things that we have, that keeps us in touch with our culture … well, one of the few things.[4]

This selection of photographs also represents what Stuart Hall calls that 'certain moment'[5] when an individual or group defines itself as 'black', African or Caribbean following migration or immigration to a country that is predominantly white. This moment encapsulates the tensions produced by such a scenario of cultural difference, as well as the possibilities of difference to generate excitement and change in Britain. The personal and cultural trauma experienced by the first generation of Caribbeans and Africans to arrive in Britain after World War II left them with a sense of being 'out of place', having left the country where their sense of self had been forged. Yet even in such an historical moment of migration and settlement, style and fashion became more than just a superficial means of cultural engagement. It was a visual and tangible affirmation of their existence, of who they were, and of their cultural and social relevance in their new 'home'.[6] For their descendants born in Britain, dress has proved to be an invaluable means of unpacking the burgeoning outcome of this situation.

As the photographs show, the various forms of dress aesthetic amongst black people in Britain encapsulate the continuity of this practice from one generation to the next. They capture fragments of time when dress was essential to the formation of the identity of an individual, a group or a specific culture. These merge to express the time, space and place of black style presence in Britain where dress has become a particular form of aesthetic poignancy. Thus, in the twenty-first century, it has reached an aesthetic moment where heredity and traditions of style, accumulated over more than 50 years, have culminated in a dynamic cultural entity moulded in part by the politics of race and

ethnicity, as well as the desire to develop a personal style from a wealth of influences. From this comes the ability to evoke visual pleasure in the observer, bringing psychological reassurance for the wearer and a consequent sense of pride. Such feelings simultaneously compound the wearer's difference while underlining their permanent place in Britain.

The dynamics of dress amongst black people in Britain are built on seams of emphatic connections and responses to dress styles originating in other parts of the diaspora, such as the Yoruba *dashiki* during the 1970s, which is enjoying a renaissance today. In such circumstances the visual engagements with cultural references and social critiques made by black people across the diaspora have connected with the experiences of most black people in Britain. A case in point is the complexity of urban life and 'ghetto' culture in the so-called 'black areas' of Birmingham, Manchester or Bristol, for example, which is to some extent reflected in parts of the US or South Africa. The particular resonance of the black British aesthetic is that much of the African diaspora is represented in Britain both by its people and by its culture, in the form of clothing and textiles. In 'black' street markets (London's Brixton Market perhaps being the most famous), African textiles are traded near Ragga garments and associated footwear, close by stalls selling bandannas and an amazing array of hair accoutrements. Superimposed on to this is the black British accent of styling clothes, an accent fortified by regional difference, from Scotland to the

Midlands to the South. Additionally, the incorporation of designer clothing and individual contributions, from home-sewing to professional styling, have enriched this particular cultural sphere. As a whole, the black British style aesthetic can claim to have developed its own particular diaspora style dialect.

One could say that to check the style and fashion of black people in Britain is to see how they have confronted the tenets of difference to present a sense of 'truth' to their individual life experience.

Dalston, London, 1992 © Syd Shelton

IRIE

The rise of black consciousness and civil rights throughout the African diaspora in the 1960s and 1970s ignited a pride in black people, particularly young people, about what it means to be black. Features that had been denigrated in the past as 'too black, too African', such as the natural texture of black hair, were celebrated. Alongside this, African dress became a symbol for their sense of place and belonging, since it served as a reminder of the cultural traditions of different parts of Africa.

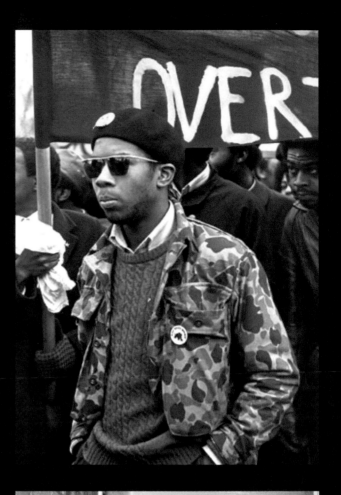

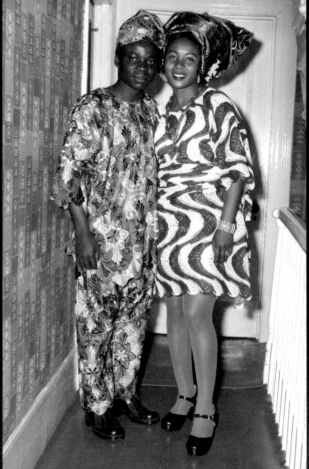

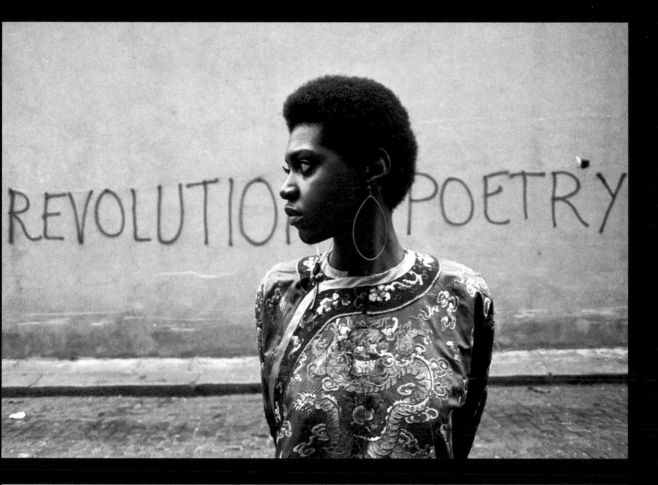

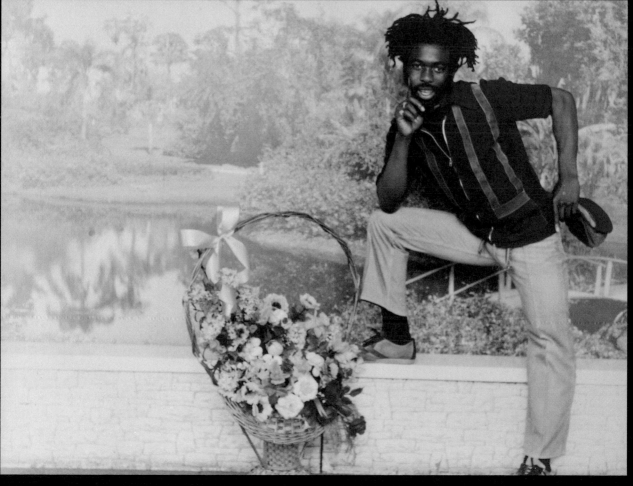

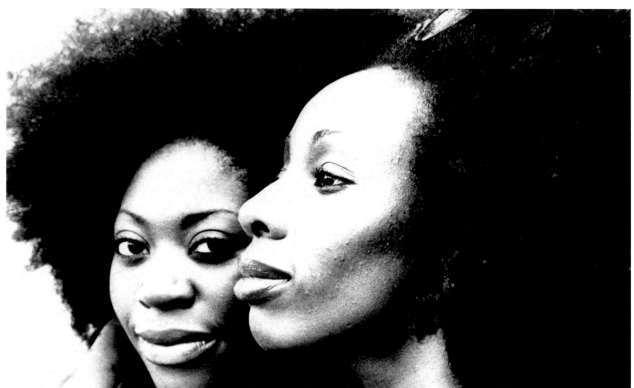

London, 1990s © Shambala/PYMCA

HAIR

Hair has long been a symbol of oppression and resistance, as well as a mark of freedom and individualization, and still remains a sensitive issue. The politics of black hair dates back to the 1700s; the tightly curled hair of slaves, for example, was seen as a mark of difference by non-whites, most notably as an emblem of their superiority to the slaves. From the early nineteenth century hair straightening was advocated as an essential part of their reconstruction as 'free' people. In the second half of the twentieth century the decision to opt for a relaxed or natural hairstyle led to friction within the African diaspora, raising questions for each individual about what black identity means.

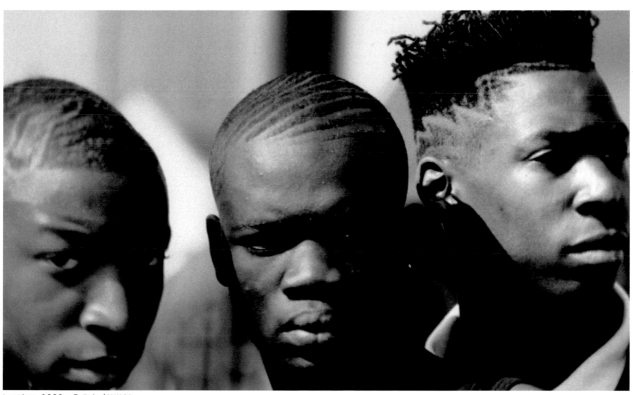

London, 1990s © Fela/PYMCA

In the twenty-first century, the range of hairstyles on offer to black women and men is incredible. Hair can be bleached blonde; relaxed and dyed any colour; or arranged into a bouffant of asymmetrical towering curls. Wigs and hair extensions are used as casually as hair accessories, and the Afro and dreadlocks are re-emerging as significant representations of black identity. Yet despite the long history of black hairstyles and their resistance to the denigration of a black identity, the decisions black men and women make about their hairstyles can cause consternation. Hair extensions can be seen as a sign of fraudulence and disrespect to one's authentic black identity; and dreadlocks can still ignite family feuds, despite their ubiquitous presence and the honourable religious beliefs they often represent. All are valid, however, in the contribution black hairstyles make to black aesthetics and to the different ways black people can be modern.

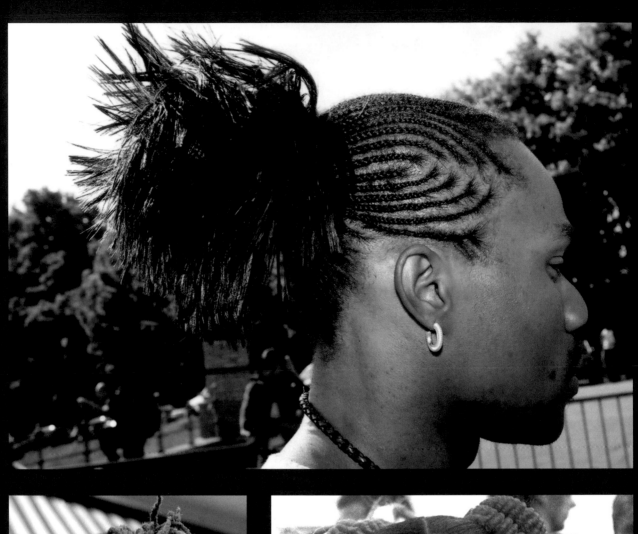
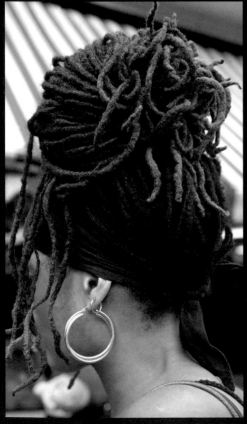
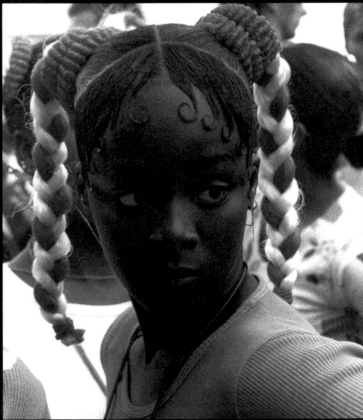

Studio portrait of a bus conductor, Birmingham, c. 1950 © Ernest Dyche/Birmingham Central Library

Skylarking, skylarking
That's what youth do today
Skylarking, skylarking
Before they stand up firm on their feet
Get a likkle work, a likkle work
And earn their bread honestly...
So if you all keep on doing
what you all are doing
You will end up, up, up in jail
'Skylarking',
Horace Andy, 1972

'FIX UP,
LOOK SHARP'

To present oneself to the public as the best one can be is a tenet that is passed on from generation to generation. This is at its most obvious on formal occasions. An invitation to a wedding can trigger a shopping spree for a completely new outfit, from underwear to outer garments. The result often inspires a visit to a local high-street photographer to procure a permanent record of the successful look.

The studio photograph opposite shows two men wearing gangster-inspired clothing that was popular amongst men in the early to mid-1970s. In 1972 Horace Andy recorded 'Skylarking', which dominated the reggae world. The outfits, like the song, make reference to a lifestyle that exists outside the law.

West Bromwich, c. 1975 © Vanley Burke/Birmingham Central Library

Birmingham, 1950s © Ernest Dyche/Birmingham Central Library

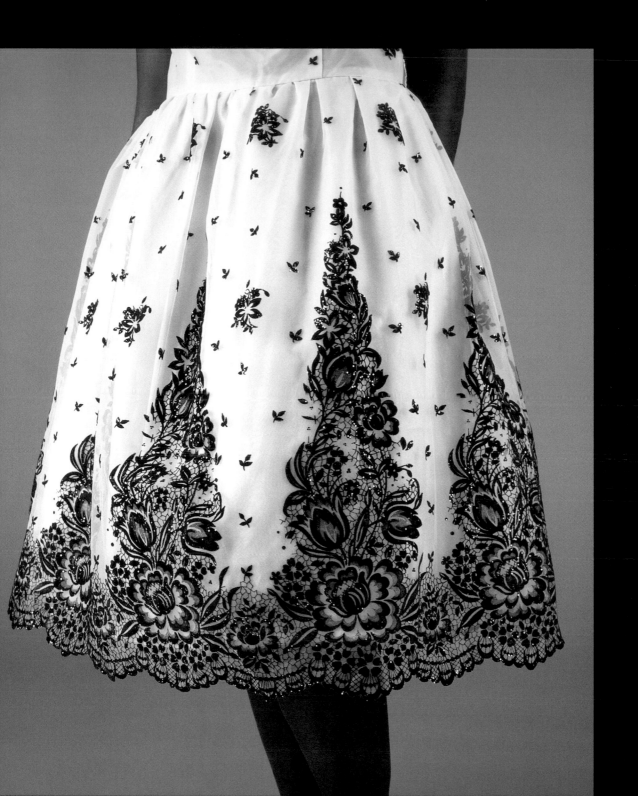

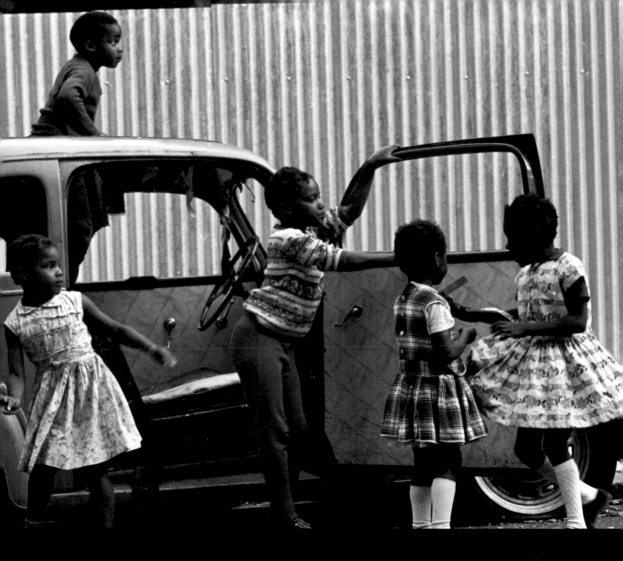

KIDS

The clothes worn by children are generally determined by their parents, and the style ideals of the parents are often reiterated in the clothes they choose for their offspring. They may also project family values, such as a conservative attitude to gender divisions: dressing little girls in pretty frou-frou dresses, lacy socks and patent leather shoes, for example. Alternatively the early 1980s saw the tracksuit take off as a fashion craze for all ages. The three young Londoners pictured opposite encapsulate the current currency of the tracksuit as urban wear. This had been established in the 1970s when the two-piece was worn predominantly by black men, the most

iconic representative being Bob Marley. Beaded canerows, the fashionable hairstyle of that moment, were also worn by adults such as Stevie Wonder and Patti Boulaye. The addition of the roller skates recalls the craze of the early 1980s. Essentially, the children sport the up-to-the minute style of the early 1980s and would have been the envy of their contemporaries.

London, 1995 © Giles Moberly

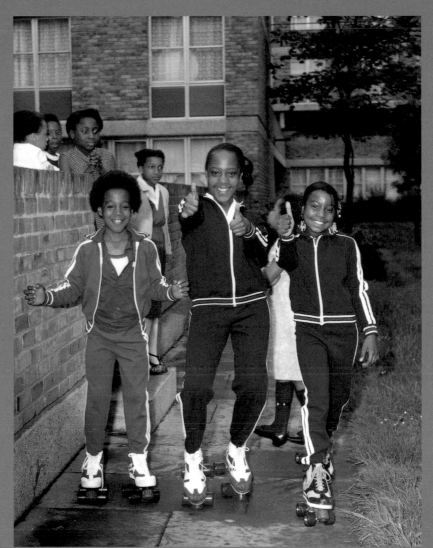

London, 1980s © Harry Jacobs/The Photographers' Gallery

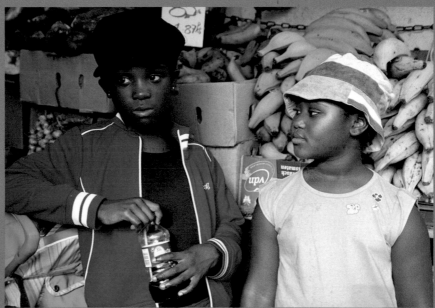

London, 2003 © lydiaevans.com

'WIN THE LOST AT ANY COST'

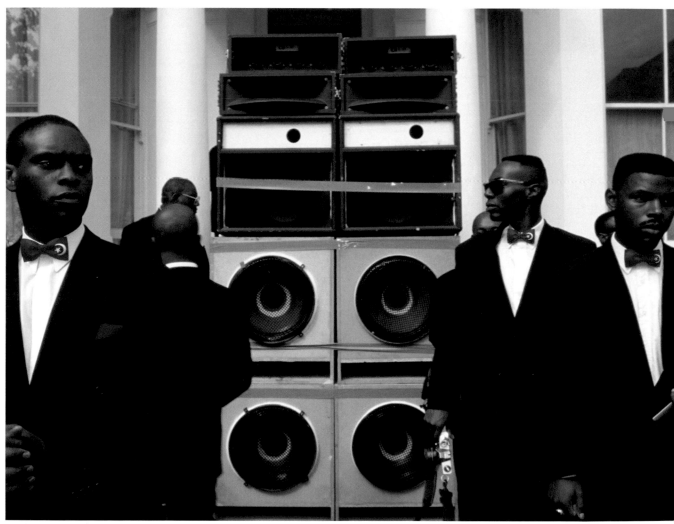

London, 1994 © Giles Moberly

Religion is a central feature of black culture. How the body is dressed must reflect the respectability and goodness that helps to mark one out from the non-believer. The men of the Nation of Islam, established in the 1930s and founded under African-American Elijah Muhammad, adopt a uniform, complete with the signatory bow-tie and Nation of Islam ensign, that 'claims respectability and demands the audience's attention'. Their uniformity is further cemented through the close-shaven hairstyles. All these elements conform to the description of black Muslim men in America by Malcolm X in the early 1960s as being 'quietly, tastefully dressed'.

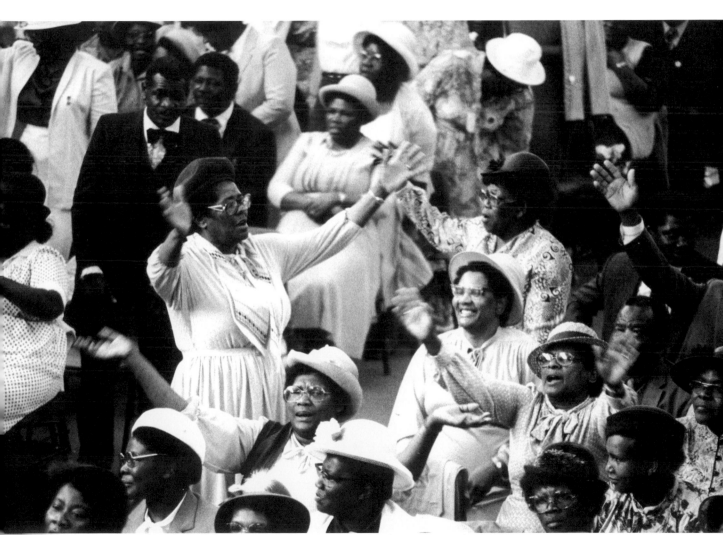

Black Church Convention, Bingley Hall, Birmingham, 1987 © Vanley Burke/Birmingham Central Library

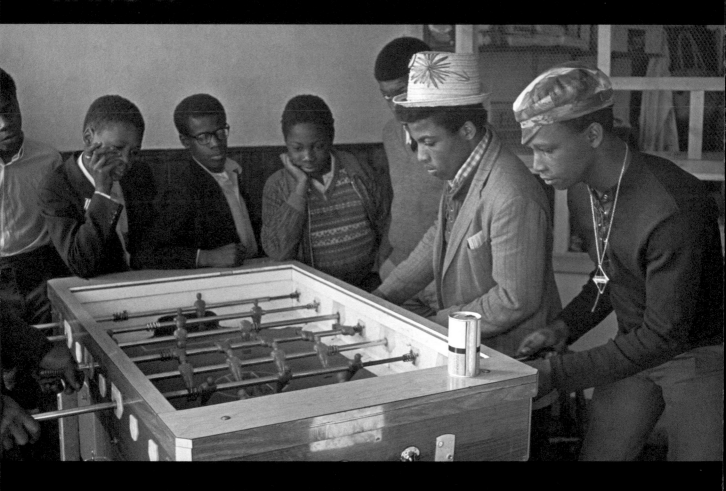

'My name is Rasky listen to my flow
I socialise in Hackney and Bow
I wear my trousers ridiculously low ...
My name is Rasky listen to my slang
I socialise with the crew and the gang
Those youths on the street is where I hang.'
'Cut 'em Off', Dizzee Rascal, 2003

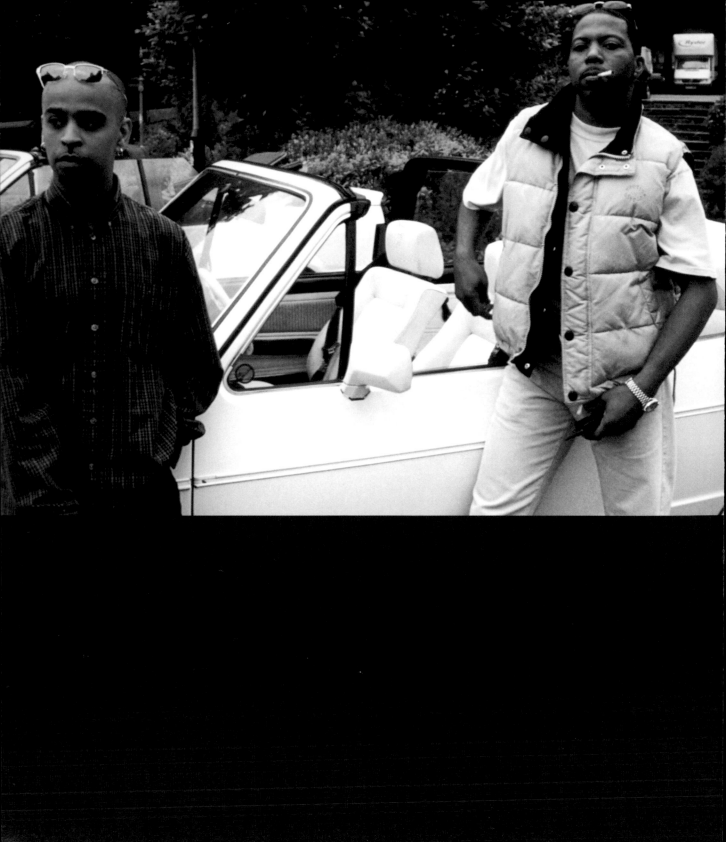

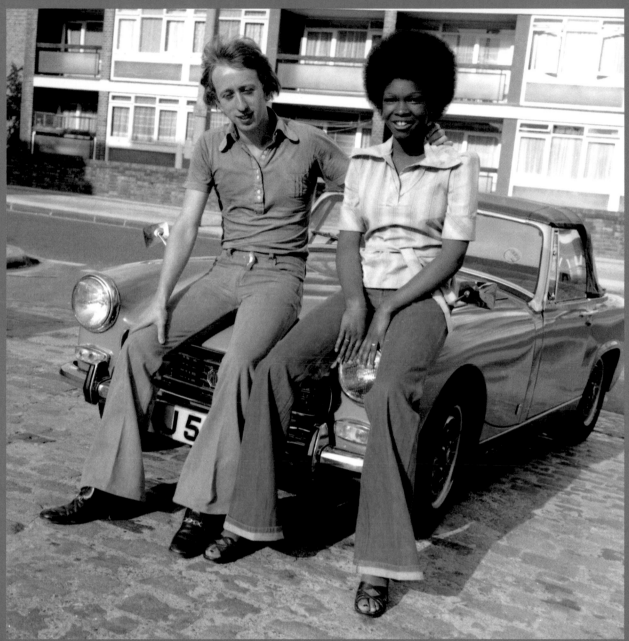

London, 1970s © Brian Bandele 'Tex' Ajetunmobi

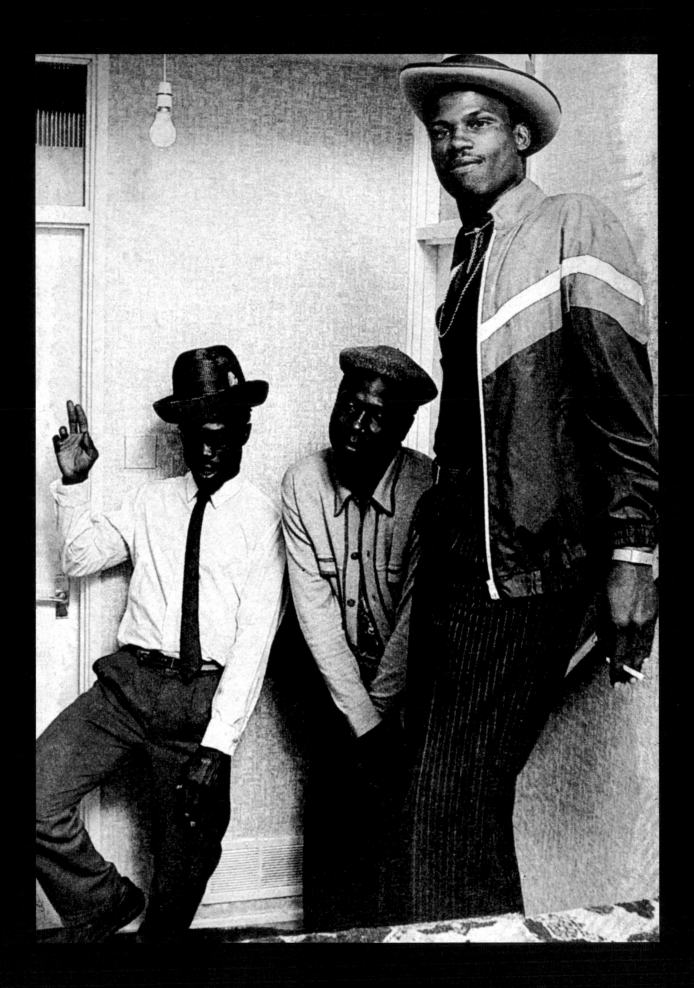

CLUBBING

'With their roots in the rent parties and shebeens of the early migrants, blues parties were unanimously agreed ... to be the "blackest" social events, as well as the least formal.'
Claire Alexander,
The Art of Being Black, 1996

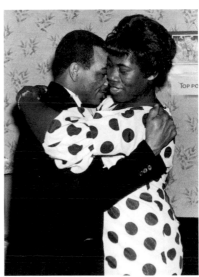

Birmingham, *c.* 1970 © Vanley Burke/ Birmingham Central Library

The night-life in black clubs, blues and house parties gives full vent to black aesthetics. In a space where the decibel level makes body language the most effective means of communication, clubbers have the opportunity to indulge in their dress fantasies, in an atmosphere bent on free expression.

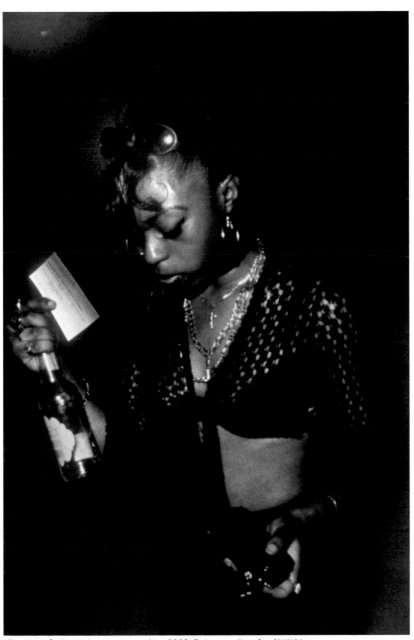

Liberty's @ The Colosseum, London, 1999 © Darren Regnier/PYMCA

1999 © Giles Moberly

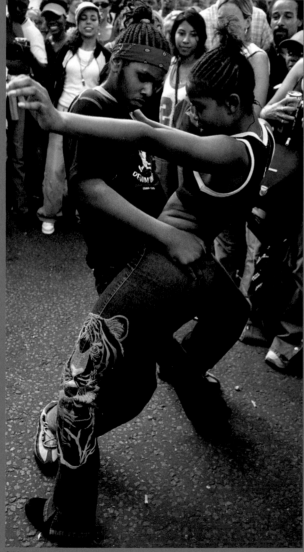

CARNIVAL

'Every spectator is
a participant –
carnival is for all who
dare to participate'
Notting Hill Carnival Motto

2003 © Bryn Reade
opposite: 2003 © Bryn Reade

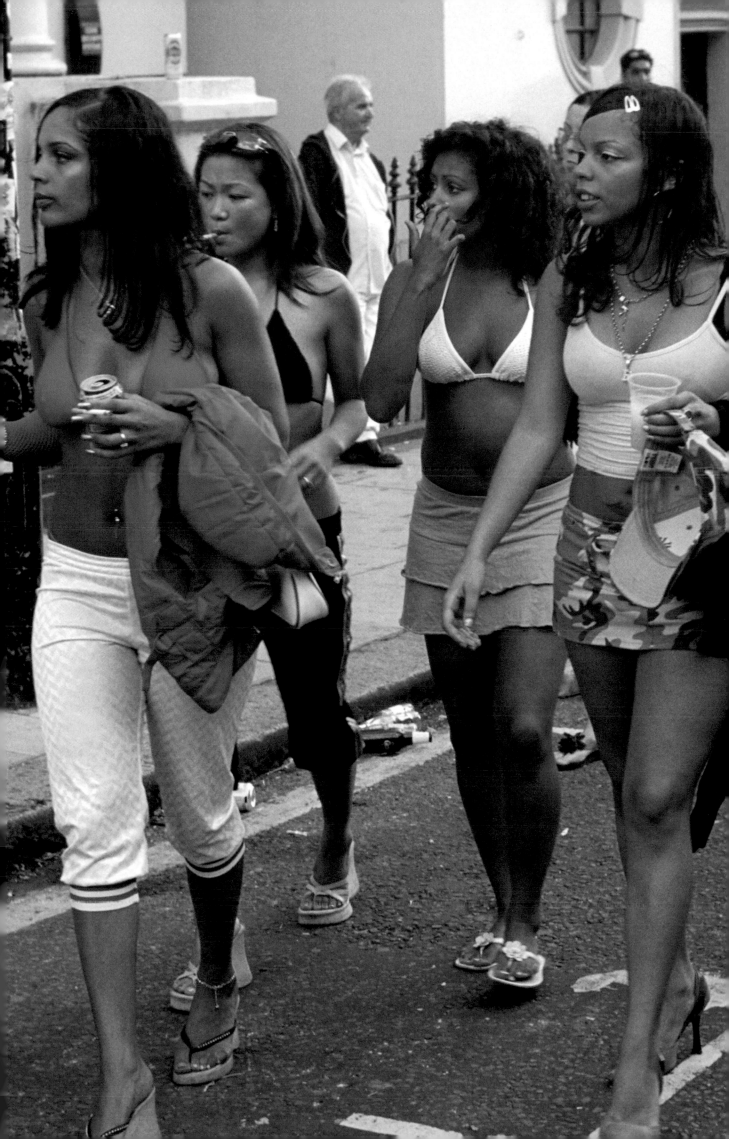

Carnival has been
defined as a site for
'social catharsis and a
celebration of freedom'.
This is translated in the
outfits worn by
spectators, who annually
try to match the
spectacle of carnival
costumes, creating a
visual sensation for
which the event is
internationally famous.

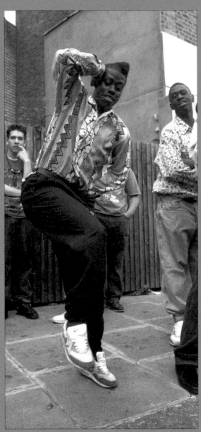

1990 © Giles Moberly

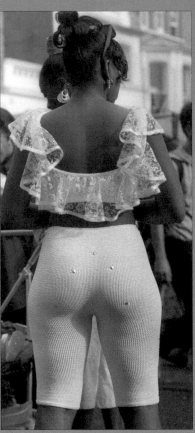

1993 © Giles Moberly

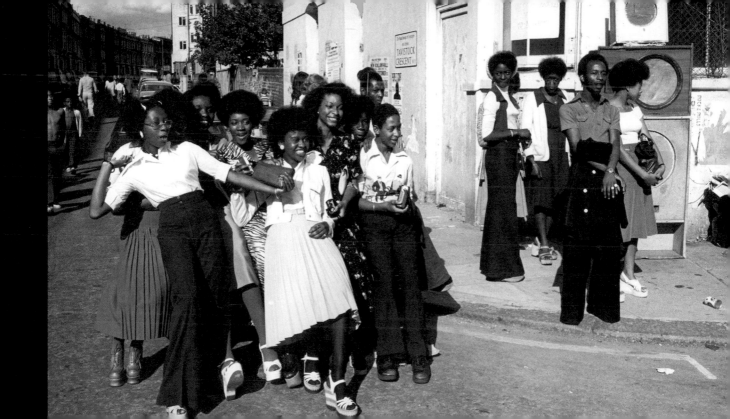

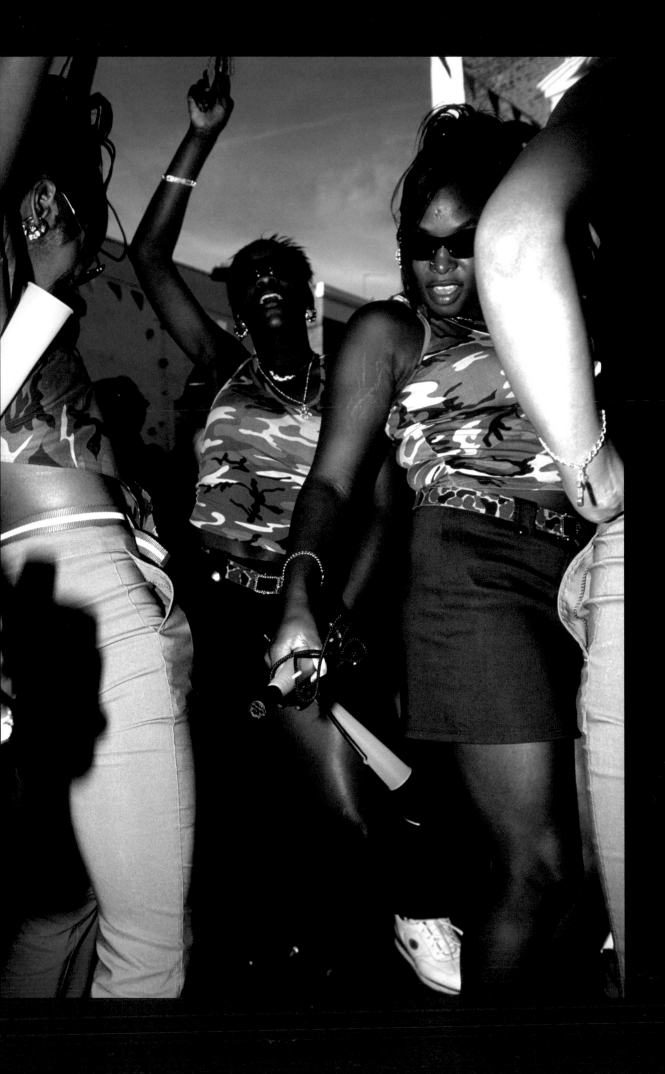

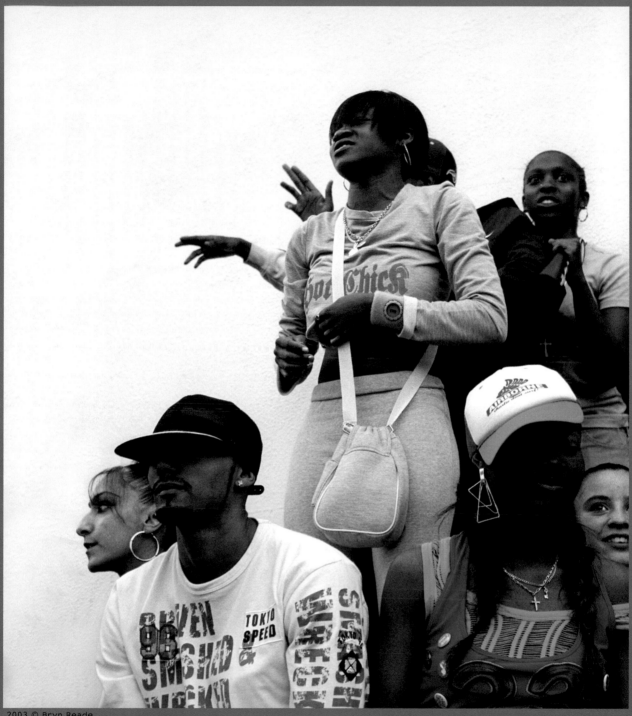

2003 © Bryn Reade

Birmingham, 2000 © Max Kandhola

DETAIL

'The particulars or items of any
whole considered collectively'
Oxford English Dictionary

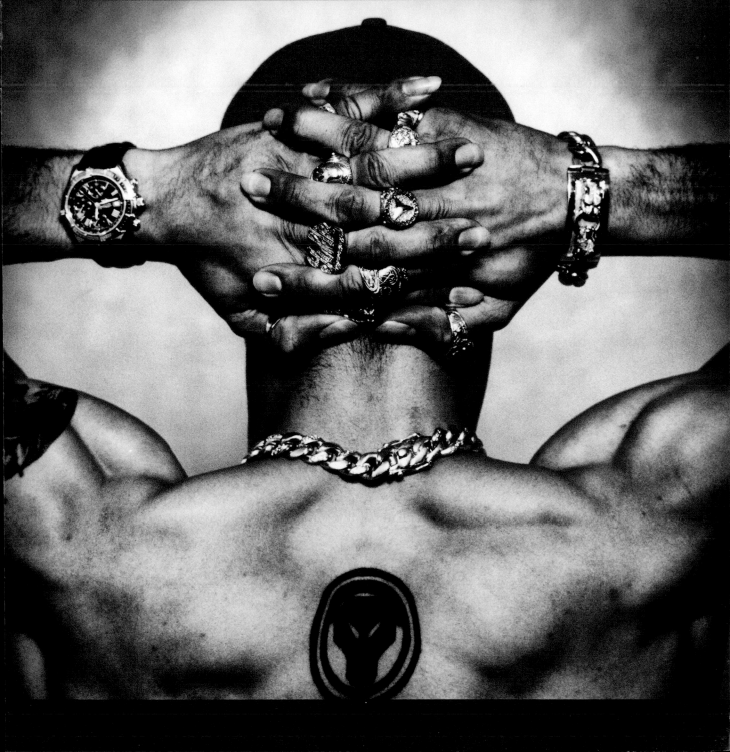

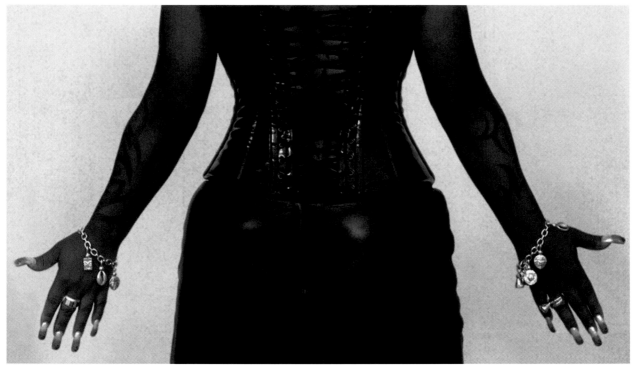

Day of Record, V&A Museum, 2003

Trainers customized for Birmingham International Carnival, 1993 © Susan Green/Birmingham Central Library

Accessories are the 'magic touch' deployed to perfect a desired look. Items that dress the head, hands and feet can, in their own right, provide a narrative on cultural and social issues.

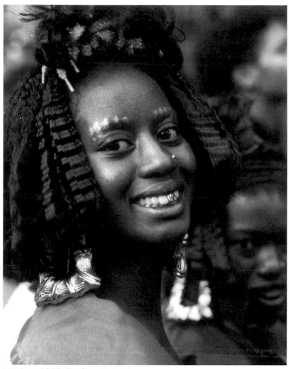

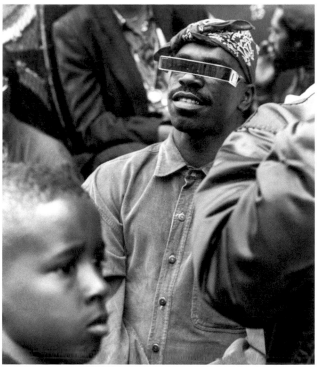

London, 1992 © Giles Moberly

London, 1995 © Giles Moberly

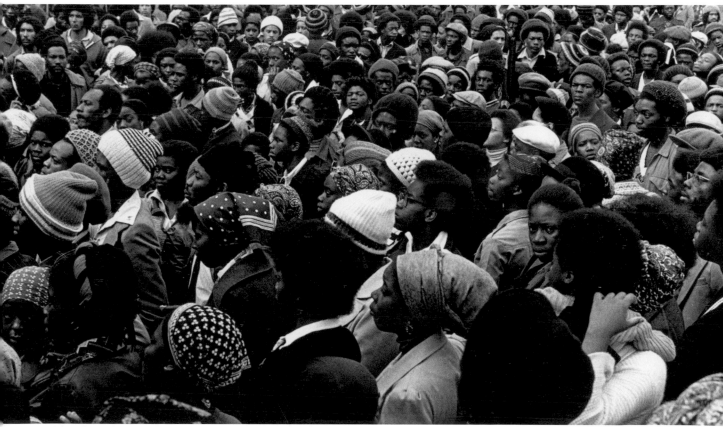

Africa Liberation Day, Birmingham, 1979 © Vanley Burke/Birmingham Central Library

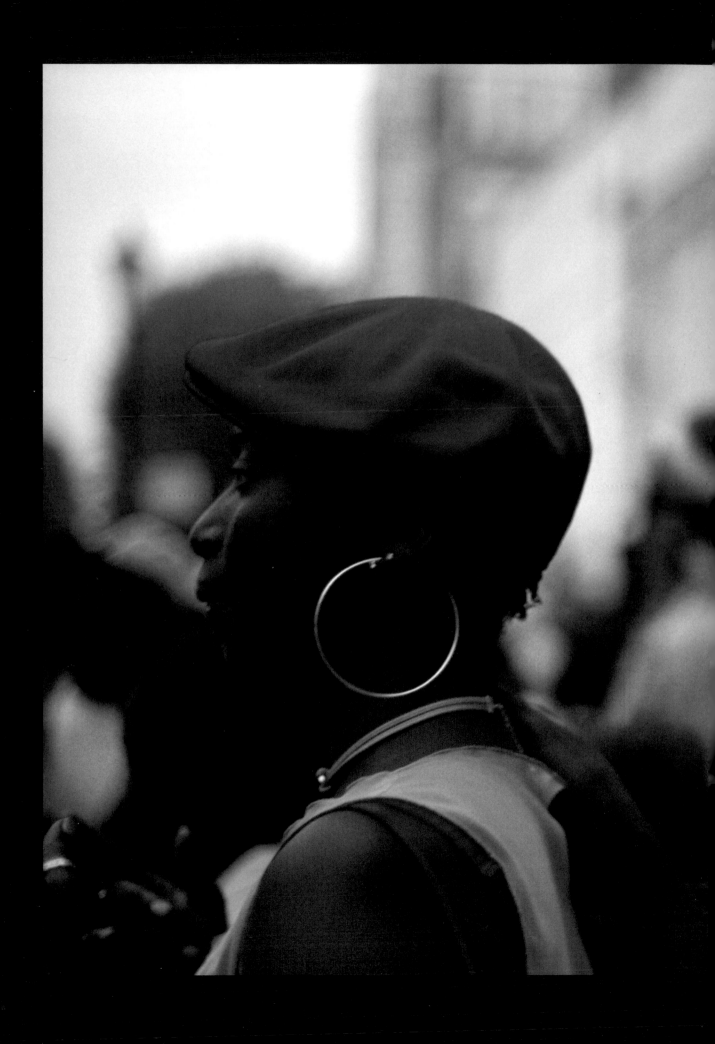

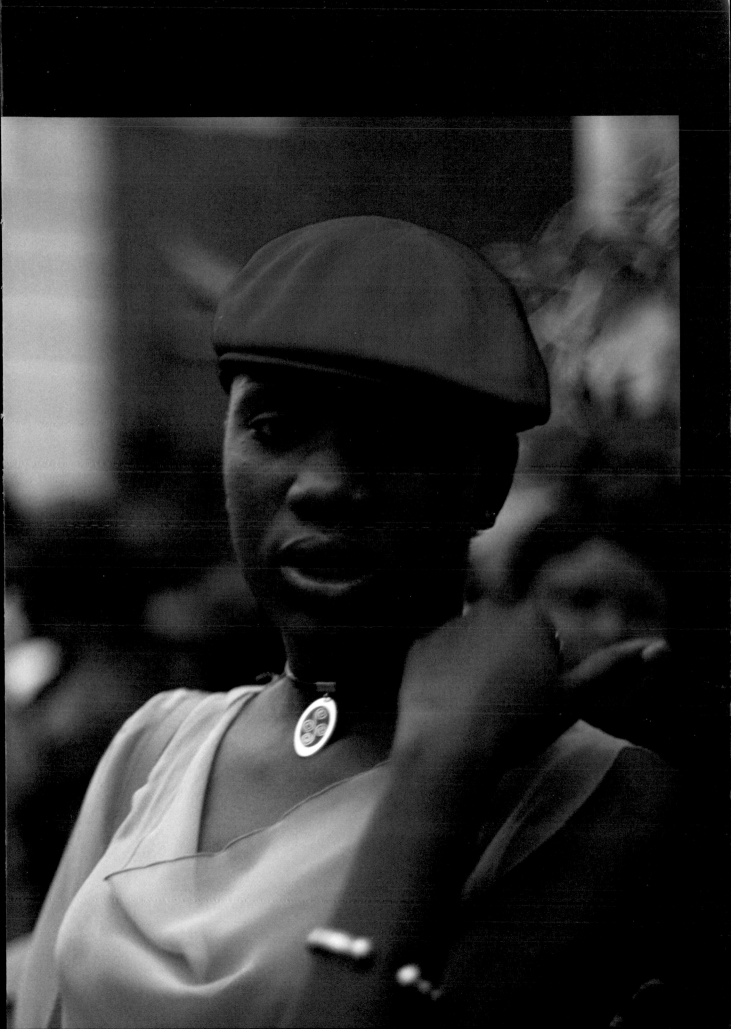

NOTES

INTRODUCTION

1. The title of a song written and performed by Tippa Irie in 1986. I am grateful to Tippa Irie for allowing me to use the title in this way.
2. Earlier studies include Eicher (1995), Robertson (1995), Hendrickson (1996), and White and White (1998).
3. Hall and Sealy (2001), p. 35.
4. Ibid.
5. Lewis (2003), pp.166–72. Van Dyk Lewis has created a table of objects of African diaspora trends which Bakri Bakhit refer to as 'an archive of black styles'.
6. Tulloch (2000), pp. 215–18.
7. Davis (1994), p. 171.
8. Ibid., p. 173.
9. Gilroy (1993), p. 181.
10. Tulloch (1991); Eshun (2001/2); Lewis (2003).
11. Hall (1990), pp. 223–5.
12. Hall and Sealy (2001), p. 36.
13. Nazer (2004), pp. 17–23.
14. Kolnai (1995), p. 63.
15. Boxhill (1995), p. 94.
16. Dillon (1995), pp. 23–4.
17. Ramirez (1996), p. 23.
18. Ardener (1989), p. 111.
19. Neal (1999), p. 3.
20. The word 'jook' has African origins, such as the Bantu word juka . Jook is also linked to the term 'juke box', that 1950s icon of music and counter-culture.
21. Neal (1999), pp. 3–9.
22. Tulloch (2003).
23. Hebdige (1979), p. 13.
24. Davies (1997), p. 4.
25. Ashenburg (2002), p. 6.
26. Crawley (1931), p. 107.
27. Tarlow (1999), p. 176.
28. Picton (2003).
29. The Yoruba word for *accra*, the Ghanaian term for an African-print fabric, thereby identifying Ghana as the historic source of this cloth tradition (Picton, 2003).
30. This quote forms part of correspondence belonging to John Picton, the author of which he wishes to remain anonymous.

WHAT TO WEAR IN WEST AFRICA

1. Mustafa (1998), pp. 19–20.
2. For surveys of the evidence and comparison with other parts of the continent, see Picton & Mack (1989), Spring & Hudson (1995).
3. Mustafa (1998), p. 15.
4. Ibid., p. 20.
5. Full explanations are given in Chapter 3 and elsewhere in Picton & Mack (1989), where details of these and other looms can be found.

6. See Byfield (2002); also Picton & Mack (1989), Barbican Art Gallery (1995).
7. See especially the work of Chris Seydou, *Revue Noire* (1998), pp. 4–5.
8. Rovine (2001).
9. Barbican Art Gallery (1995).
10. Ross (1998).
11. See Mustafa (1998), p. 32; Daly (1999), p. 354.
12. Just where the Senegalese woman's Ndockette fits into this, I am not sure; see Mustafa (1998), p. 33.
13. Mustafa (1998), p. 38.
14. See Gardi (2000), pp. 21, 23 and 38–9, women's gowns; and pp. 30–1, for a man's.
15. See Picton & Mack (1989), Barbican Art Gallery (1995), and references in the bibliographies therein. For the most recent account of their embroidery, see Gardi (2000).
16. E.g. Mustafa (1998), p. 26.
17. E.g. Picton & Mack (1989).
18. E.g. Gardi (2000), pp. 68–9.
19. Rovine (2001), pp. 24–5.
20. Geurts (2002), pp. 51–2.

BEYOND BINARIES

1. These quotes are derived from interviews in the context of a larger study of African-American style and fashion, conducted at the University of California at Davis.
2. DuBois, W.E.B., 1903/1969, *The Souls of Black Folk*. New York, NY: The New American Library.
3. Ibid.
4. Hall, Carol, 1992, 'Towards a Gender-Relational Understanding of Appearance Style in African-American Culture'. Master's Thesis, University of California, Davis.
5. Ibid.
6. A term describing the American racist culture against blacks, it originated as a derogatory way of depicting black people in the minstrel shows of early 19th-century America and was absorbed into the nation's vocabulary. Historians have used the term in reference to the process of segregation or setting the races apart, sometimes meaning customary or informal segregation and sometimes meaning legal or codified segregation.
7. hooks, bell, 1995, *Art on My Mind: Visual Politics*. New York, NY: The New Press, pp. 120, 124.
8. O'Neal, Gwendolyn S., 1998b, 'African-American aesthetics of dress: Current manifestations', *Clothing and Textiles Research Journal*, 16(4), p. 167.
9. Foster, Helen Bradley, 1997, 'New Raiments of Self': *African American Clothing in the Antebellum South*. Oxford, UK: Berg, p.24.
10. Curtin, Philip D., 1984, *Cross-Cultural Trade in World History*. Cambridge: Cambridge University Press.

11. Foster, 1997. 'New Raiments of Self': *African American Clothing in the Antebellum South*, p. 34.
12. White, Shane, and White, Graham, 1998, *Stylin': African American Expressive Culture from Its Beginnings to the Zoot Suit*. Ithaca, NY: Cornell University Press.
13. See Foster, 1997, p. 71.
14. White and White, *Stylin': African American Expressive Culture from Its Beginnings to the Zoot Suit*, 1998, p. 17.
15. Ibid., p. 36.
16. hooks, bell, 1990, *Yearning: Race, Gender, and Cultural Politics*. Boston, MA: South End Press, p. 217.
17. Foster, 1997, p. 13.
18. White and White, p. 92.
19. Hunt, Patricia K., and Sibley, Lucy R. 1994, 'African American women's dress in Georgia, 1890-1914: A photographic examination', *Clothing and Textiles Research Journal*, 12(2), pp. 20–26.
20. Foster, 1997, p. 235.
21. White and White, p. 262.
22. Gaskins, Bill, 1997, *Good and Bad Hair*. New Brunswick, NJ: Rutgers University Press, preface.
23. Kelley, Robin D.G., 1997, 'Nap time: Historicizing the Afro', *Fashion Theory*, 1(4), p. 340.
24. Kelley, 1997, 'Nap time: Historicizing the Afro', pp. 339–351.
25. See note 1.
26. Lewis, Van Dyk, 2003, 'Dilemmas in African diaspora fashion', *Fashion Theory*, 7(2), p. 164.
27. Ibid.
28. O'Neal, Gwendolyn S., 1998a, 'African American women's professional dress as expression of ethnicity', *Journal of Family and Consumer Sciences*, 90, p. 31.
29. DuBois, W.E.B. 1903/1969, *The Souls of Black Folk*, p. 45.
30. O'Neal, 1997a, 'African American women's professional dress as expression of ethnicity', p. 31.
31. Both examples from O'Neal, 1998b, 'African-American aesthetics of dress: Current manifestations', *Clothing and Textiles Research Journal*, 16(4), pp. 167–175.
32. Rabine, Leslie W., 2002, *The Global Circulation of African Fashion*. Oxford, UK: Berg Press, p. 107.
33. Ibid., p. 108.
34. West, Cornel, 1990, 'The new cultural politics of difference', in Russell Ferguson et al. (eds.), *Out There: Marginalization and Contemporary Culture*. Cambridge: MIT Press, p. 20.
35. Boyd, Todd, 1994, 'Check Yo Self Before You Wreck Yo Self: Variations on a Political Theme in Rap Music and Popular Culture', in *The Black Public Sphere Collective*, ed. The Black Public Sphere. Chicago: Chicago University Press, pp.293–316.
36. Examples from O'Neal, 1998b, 'African-American aesthetics of dress: Current manifestations', pp. 167–175.

DANCEHALL DRESS

1. Sandra Lee, interviewed on Anthony Miller's 'Entertainment Report', broadcast on Television Jamaica, Friday, 23 April, 1999. Donna Hope describes Sandra Lee thus in her M. Phil. dissertation, 'Inna Di Dancehall Dis/place: Socio-cultural Politics of Identity in Jamaica', University of the West Indies, Mona, 2001, p. 91: 'She lays claim to a legacy of urban, inner-city/downtown Kingston background and higgler/dancehall heritage that places her in a position of royalty in the dancehall dis/place. Her arrival at any dancehall event, major, minor or otherwise is heralded by an announcement over the sound system and her high status in the dancehall dis/place is consistently re-presented and legitimized by the consistent symbolizing and legitimizing of her presence at this event.'
2. 'Picky-picky head': a derogatory Jamaican creole expression. The Dictionary of Jamaican English cites the following 1960 usage: 'when a girl's hair is very short, grows close to the scalp in little balls of fluff, very negroid'.
3. 'Tall hair': a Jamaican colloquialism for long, flowing hair.
4. 'Sisterlocks': similar to dreadlocks, except that the locks are much thinner.
5. Ingrid Banks, *Hair Matters: Beauty Power, and Black Consciousness*, New York: New York University Press, 2000, p. 69.
6. Ibid., p. 3.
7. Buchi Emecheta, *The Joys of Motherhood*, 1979; repr. London: Heinemann, 1980, p. 71.
8. For this anecdote, I am indebted to Professor Hubert Devonish, Department of Language, Linguistics and Philosophy at the University of the West Indies, Mona, Jamaica. A rough translation of the verse: 'For figure and face I didn't place; but for boobs and arse I busted their arse.'

CHECK IT

1. Ginsburg (1990), p. 10.
2. Ibid., p. 8.
3. This was part of the London-wide project and exhibition 'Local Heroes: Twelve Black and Asian Londoners give a piece of history to our local museums' (2003), which was an initiative of the London Museums Agency.
4. Zarrah Ahmed-Kadi in interview with Alice Mayers, Bromley, London, 2003.
5. Hall (1993), p. 136.
6. Tulloch (1999, 2002).

FURTHER READING

Barbican Art Gallery (John Picton et al). *The Art of African Textiles: technology, tradition and lurex* (London: Lund Humphries, 1995, reprinted 1999)

Boyd, Todd. 'Check Yo Self Before You Wreck Yo Self: Variations on a Political Theme in Rap Music and Popular Culture', in *The Black Public Sphere Collective*, ed. The Black Public Sphere (Chicago: Chicago University Press, 1994), pp. 293–316.

Byfield, Judith. *The Bluest Hands, a social and economic history of women dyers in Abeokuta* (Oxford: James Currey, 2002)

Calefato, Patrizia. 'Fashion and worldliness: Language and imagery of the clothed body', *Fashion Theory* (1997), 1(1), pp. 69–90.

Collins, Patricia Hill. *Black Feminist Thought: Knowledge, Consciousness, and the Politics of Empowerment* (New York, NY : Routledge, 1990)

Cooper, Carolyn, *Sound Clash: Jamaican Dancehall Culture at Large* (Palgrave MacMillan, 2004)

Curtin, Philip D. *Cross-Cultural Trade in World History* (Cambridge: Cambridge University Press, 1984)

Daly, M. Catherine. '"Ah, a real Kalabari woman!" Reflexivity and the conceptualization of appearance', *Fashion Theory*, (1999), 3, 3, pp. 343–62.

Dogbe, Esi. 'Unraveled Yarns: Dress, Consumption, and Women's Bodies in Ghanian Culture', *Fashion Theory* (2003), 7, 3-4, pp. 377–396.

Drewal, Henry John. 'Beauty and being: aesthetics and ontology in Yoruba body art', in Arnold Rubin (ed), *The Marks of Civilization* (University of California, Los Angeles, 1988) pp. 83–96.

DuBois, W.E.B. *The Souls of Black Folk* (New York, NY: The New American Library, 1903/1969)

Eicher, Joanne B. (ed). *Dress and Ethnicity: Change Across Space and Time*, (Oxford, Washington D.C.: Berg, 1995)

Eshun, Ekow. *Seen: Black Style UK* (London: Booth-Clibborn Editions, 2001)

Foster, Helen Bradley. *'New Raiments of Self': African American Clothing in the Antebellum South* (Oxford: Berg, 1997)

Gardi, Bernhard. *Le Boubou – c'est chic* (Basel: Museum der Kulturen, 2000)

Gaskins, Bill. *Good and Bad Hair* (New Brunswick, NJ: Rutgers University Press, 1997)

George, Nelson. *Hip Hop America* (New York, NY: Penguin Books, 1999) Ginsburg, Madeleine. The Hat: Trends and Traditions (London: Studio Editions Ltd., 1990)

Hall, Carol. *Towards a Gender-Relational Understanding of Appearance Style in African-American Culture* (Master's Thesis, University of California, Davis, 1992)

Hall, Stuart. 'Minimal Selves', in Gray, A. and McGuigan, J. (eds), *Studying Culture: An Introductory Reader* (London: Edward Arnold, 1993)

Hendrickson, Hildi (ed). *Clothing and Difference: Embodied Identities in Colonial and Post-Colonial Africa*, (Durham, N.C., London: Duke University Press, 1996)

hooks, bell. *Yearning: Race, Gender, and Cultural Politics* (Boston, MA: South End Press, 1990)

hooks, bell. *Art on My Mind: Visual Politics* (New York, NY: The New Press, 1995)

Hunt, Patricia K., and Sibley, Lucy R. 'African American women's dress in Georgia, 1890–1914: A photographic examination', *Clothing and Textiles Research Journal* (1994), 12(2), pp. 20–6.

Kelley, Robin D.G. 'Nap time: Historicizing the Afro', *Fashion Theory* (1997), 1(4), pp. 339–51.

Lewis, Van Dyk. 'Dilemmas in African diaspora fashion', *Fashion Theory* (2003), 7(2), pp. 163–90.

Lynch, Annette. *Dress, Gender and Cultural Change: Asian American and African American Rites of Passage* (Oxford, New York: Berg, 1999)

O'Neal, Gwendolyn S. 'African American women's professional dress as expression of ethnicity', *Journal of Family and Consumer Sciences* (1998a), 90, pp. 28–33.

O'Neal, Gwendolyn S. 'African-American aesthetics of dress: Current manifestations', *Clothing and Textiles Research Journal* (1998b), 16(4), pp, 167–75.

Philips, Tom (ed). *Africa, the art of a continent* (London: Royal Academy, 1995)

Picton, John and Mack, John. *African Textiles* (British Museum, 1989, 2nd edn)

Prince Claus Fund, *The Art of African Fashion* (The Hague: Prince Claus Fund, and Asmara and Trenton NJ: Africa World Press, 1998)

Rabine, Leslie W. 'Scraps of culture: African style in the African American community of Los Angeles', in Elazar Barkan and Marie-Denise Shelton (eds), *Borders, Exiles, Diasporas* (Stanford, CA: Stanford University Press, 1998)

Rabine, Leslie W. *The Global Circulation of African Fashion* (Oxford: Berg, 2002)

Revue Noire. Special Mode/Fashion (Dec 97/Jan-Feb 1998), no. 27.

Robertson, Glory. 'Pictorial Sources for Nineteenth-Century Women's History: Dress as a Mirror of Attitudes to Women', in Shepherd, V., et al. (eds), *Engendering History: Caribbean Women in Historical Perspective* (Kingston, Jamaica: Ian Randle Publishers, 1995)

Ross, Doran. *Wrapped in Pride* (University of California, Los Angeles, 1998)

Rovine, Victoria. *Bogolan* (Smithsonian Institution, Washington DC, 2001)

Spring, Christopher and Hudson, Julie. *North African Textiles* (British Museum, 1995)

Tulloch, Carol. 'There's No Place Like Home: Home Dressmaking and Creativity in the Jamaican Community of the 1940s to the 1960s' in Burman, B. (ed.), *The Culture of Sewing: Gender, Consumption and Home Dressmaking* (Oxford: Berg, 1999)

Tulloch, Carol. 'That Little Magic Touch: The Headtie' in Wilson E., and de la Haye, Amy (eds) *Defining Dress: Dress as Object, Meaning and Idenity* (Manchester: Manchester University Press, 1999)

Tulloch, Carol. 'Strawberries and Cream: Dress, Migration and the Quintessence of Englishness' in Breward, C., Conekin, B. and Cox, C. (eds), *The Englishness of English Dress* (Oxford: Berg, 2002)

West, Cornel. 'The new cultural politics of difference', in Russell Ferguson, et al. (eds), Out There: *Marginalization and Contemporary Culture* (Cambridge: MIT Press, 1990), pp. 19–38.

White, Shane, and White, Graham. *Stylin': African American Expressive Culture from Its Beginnings to the Zoot Suit* (Ithaca, NY: Cornell University Press, 1998)

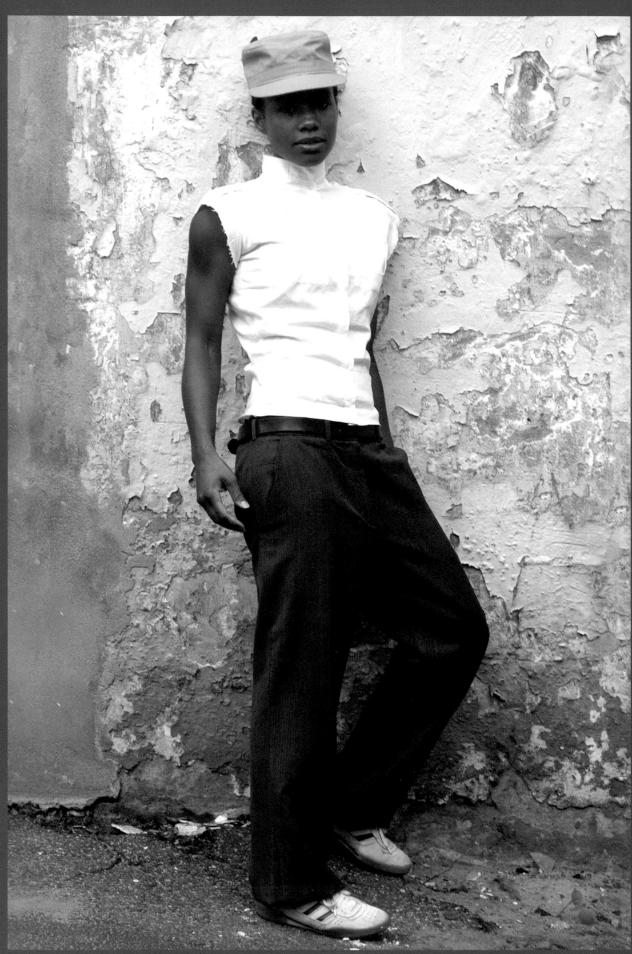

Designer Zohra Opoku, Hamburg, 2003 © Dinah Hayt